THE ART OF *Pamela Kay*

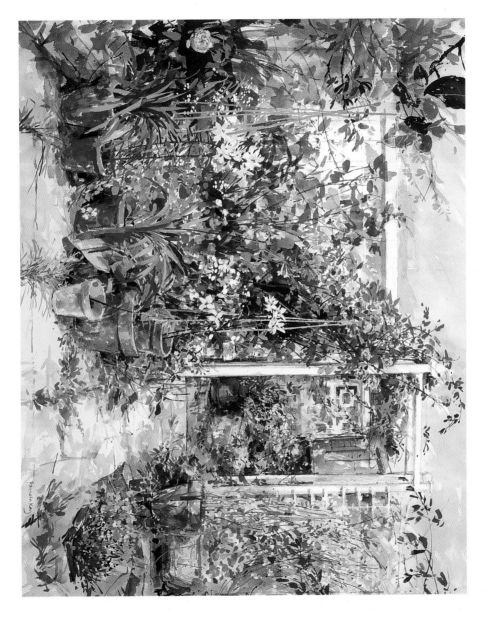

The Bottom of the Garden
By courtesy of The Catto Gallery, London

(see p110)

THE ART OF Pamela Kay

MICHAEL SPENDER

David & Charles

For my father

ACKNOWLEDGEMENTS

It is always an honour to be given access to a painter's art and thoughts, and Pamela Kay's co-operation in this venture has been all one could have wished for. The many hours of interviews were full of interest and laughter, as were several excellent lunches in her kitchen. Tony Bryan, ARPS, took all the photographs, and for this splendid feat, as well as for his admirable administration, patience and good humour, he has all my thanks. Alison Elks has been a sympathetic editor and Helen Spender has made many helpful observations on the text. Those who have particularly encouraged the production of the book and its associated exhibition include Charles Bartlett PPRWS, Gillian Catto and Leslie Worth, PRWS, who also deserve my thanks.

Michael Spender

A DAVID & CHARLES BOOK

Text © Michael Spender and Pamela Kay, 1993
Illustrations © Pamela Kay and Tony Bryan, 1993
First published 1993
Reprinted 1996

Michael Spender and Pamela Kay have asserted their right to be identified as authors of this work in accordance with the Copyright, Designs and Patents Act 1988.

British Library Cataloguing in Publication Data
A catalogue record for this book is available from the British Library.

ISBN 0 7153 0032 6

Typeset and designed by
ABM Typographics Ltd, Hull
and printed in Singapore
by C. S. Graphics Pte Ltd
for David & Charles plc
Brunel House Newton Abbot Devon

PAGE 2
Chair under the Apple Tree
(Detail, *see* p109)

PAGE 6
Self-Portrait with Still Life
(Detail, *see* p16)

CONTENTS

Acknowledgements 4

Life, Work and Art 7

Family 15

Travels and Interiors 20

Cupboards 34

Still Life 46

Flowers 82

Gardens 101

Index of Works 128

Self-Portrait as a Student – Sepia
Oil on canvas, 1958, 11½x9½in (29x24cm)

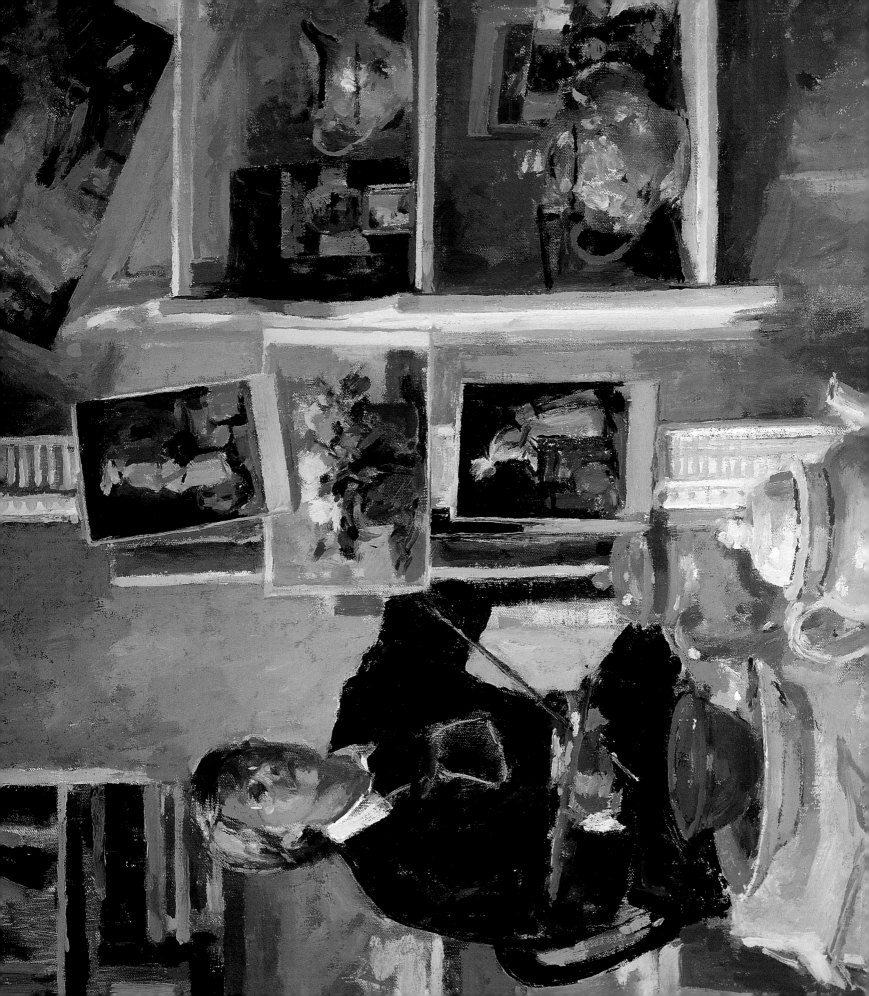

LIFE, WORK AND ART

Naturalism, which might be defined as catching a likeness of the objective world, runs as a thread through art history, which includes the Dutch still life, Impressionism and modern British academic painting. This is Pamela Kay's lineage as an artist. In her best-known incarnation as a painter of still life and flowers she takes a more distinguished place in the tradition of this essentially Naturalist genre than many of her contemporaries.

Even a Naturalist painter can be an individualist and a good one like Pamela Kay is not simply a camera. But what does she look for in the objective world and how does she seek to convey what she finds? It is hoped that the illustrations that follow will answer these questions and also demonstrate what differentiates her art from the received image of contemporary still life as a rather dull, precious affair.

Pamela Kay's works are neither dry botanical studies, nor florid generalisations. Her vivid floral world is as certainly recognisable to the botanist as her teacups are to the antique collector. Although as an artist she is an all-rounder, she chooses the still life as an appropriate means of expression, and as the vehicle for a search:

'My paintings may be all things to all men, but from my point of view they are looking for a rarer truth. All paintings are self-portraits and if you have a strict regard for truth, you can't mess about with it. In the end there is a need to get the subject right, a need to show it as it is, because it is always so much more beautiful than most people realise. Painting is a way of opening an eye, because you are showing people the world through your eyes.

'After I had been to Norwich Castle Museum to look at the Cotmans, suddenly the surrounding area was a moving Cotman. Cotman had opened my eyes to the landscape that was around him and I was seeing his vision. Not everyone can do that and it shows the enormous truth of his vision. A by-product of doing still life is the desire to open people's eyes to how beautiful very ordinary objects can be, those which people take for granted, as, say, just a cup and saucer. In painting such objects I want people to share them with me and then go back and look at their own cups and saucers in a new light.

'You don't have to spend a fortune and you don't have to search to the other end of the earth to find beauty. It's a bit like a Chinese proverb: you go on a long journey in search of the rare and beautiful and return only to find that it was back where you started all the time. I like to work in my own space, and if I am outside I have to be invisible, because I don't like to interrupt what other people are doing. I suppose all that is a reflection of my personality. In the end, whatever you do, you cannot help but that your work becomes a reflection of your personality.'

In leafing through the pages of this book, we are passing through Pamela Kay's world. It is generally an intimate, domestic world, in which crockery is rearranged on a cupboard, bread ordered from the baker in the high street and flower pots moved around the paved garden like pawns on a chessboard. It is a world seen with absolute clarity and faithfulness, yet with a sophisticated compositional sense and aesthetic that owe much to the masters in her hall of fame: the still-life artists of seventeenth-century Holland

and Spain, and painters such as Jean Baptiste Simeon Chardin (1699–1779), Henri Fantin-Latour (1836–1904), Claude Monet (1840–1926) and Edouard Vuillard (1868–1940). Among moderns and contemporaries she has been notably affected by the work of Allan Gwynne-Jones (1892–1982), John Ward (born 1917) and Bernard Dunstan (born 1920). Although it is domestic in character, the scale, breadth, variety and animation of Pamela Kay's world is a reflection of all these influences. Within carefully established parameters she seems to find an inexhaustible range of subject matter and helps to lay to rest any misconception that still life is inherently dull. How is this achieved?

'I think that if I am bored with a picture, so will other people be. I have a low boredom threshold, so if I start to get bored with a painting before anyone else does, I can do something about it at that point. What makes a painting interesting is not just the variety of colour and shape, although that is vital, but also the variety and weight of tone. In my painting I am aiming for constant variety, trying to keep it alive and sparkling the whole time. If a picture sparkles, people perhaps won't walk past it so quickly.

'I don't expect people to be conscious of this when they decide they like a painting. Pictures either speak to you or they don't. You are either drawn to them or not and you don't know why you are drawn to one rather than to the other. But if you think about it hard, you will probably find that variety is one of the major reasons why you look at one thing and do not bother with another. A bland painting is always going to be bland and your reaction to it is likely to be bland.'

In the following thumb-nail sketch of Pamela Kay's life we will look at a few early pieces, then at her paintings and drawings of her family and acquaintances. Most of the works illustrated in subsequent chapters date from the last six or seven years. The journey they chart takes in her travels (mainly with restaurant interiors), before we move into the rooms of her own house near the north Kent coast, then into her studio, where we watch an ever-changing drama of still-life objects and enough flowers to stock a florist's shop. We finally emerge from the house to look at gardens, and in particular her own garden, in every seasonal mood. En route we will see that Pamela Kay is capable of breathing life into both the most over-painted and the least considered of subjects.

Setting out on this journey was not yet on the mind of the girl in the third year of a four-year course at Canterbury College of Art who looks quizzically out of the monochrome *Self-Portrait as a Student.* With two happy years behind her, she was now restless and unsure about continuing her course, although she was persuaded to stay. She had been working as assistant to John Ward and the world of the professional artist seemed more alluring than two more years at college:

'The awful thing was that I couldn't see where to go. As I said, I get bored very easily. I remember hiding away up in the dress department, in a small corner, with one of their long mirrors. I used a reclaimed canvas, with what may have been a wonderful Victorian painting on it, and slapped some white over it to make a fresh ground. I then painted in near-transparent sepia oils. I think that in this picture I look, and indeed was, pretty perplexed and discontented.'

Pamela Kay was born on the Isle of Sheppey, in the Thames Estuary, a few months before the outbreak of World War II. She describes the atmosphere there as Dickensian, with old hulks

anchored around the coast. Although her parents were not well off and had two sons younger than Pamela to look after, they still encouraged her to pursue her interest in art.

Grammar school was intended to mould girls for nursing or teaching. Pamela recalls that her art teacher was a woman who had in her time qualified to enter the Royal College of Art, but whose parents had refused to pay the fees. 'She was bitter about that for the rest of her life. She was a good painter, and within appalling limitations she was a good teacher. But she would keep calling art "fun", which I hated. Art isn't "fun", it's bloody hard work, and somehow that grated a bit.'

After 'O' levels Pamela left for Canterbury College of Art, which she had chosen in preference to Medway because someone had told her that the Medway course was relatively unstructured. She was pleased to find Canterbury more serious and traditional in its approach and, as it turned out, that she was among the last students to be taught drawing by artists who had themselves been taught by draughtsmen, mainly at the Royal College. Those handing on the tradition included Chris Alexander, Alec Vickerman and Eric Hurren – all good artists who opted to teach rather than to strive for national recognition. In his annual reports, Eric Hurren seems to have had the measure of his student's qualities: 'Her metier seems to be painting from observation, still-life and life subjects . . . good draughtsmanship has been the foundation upon which she has developed . . . she has always shown a vital and enthusiastic approach to her work and this, together with obvious intelligence, has made the problem of teaching her a pleasant one.'

From Chris Alexander she learnt to take a sketch-book everywhere, revelling in shared youthful enthusiasm for the visual world that she describes as naive compared to the sophistication of today's students. At weekends she would draw the debris of war in the dockyards at Sheerness,

or she would make studies of the Canterbury streets, as yet untouched by town planners.

'Towards the end of the second year, I was working away one day on a lino print in the main building. The place was deserted; for some reason everyone else had cleared off. John Ward came in with the principal, Mr Moody. He was looking for an assistant and there was only me around, so I went off to work for him for the summer holidays. He had recently moved into his house and wanted me to help him do a mural in the nursery. I took one look at a magnificent

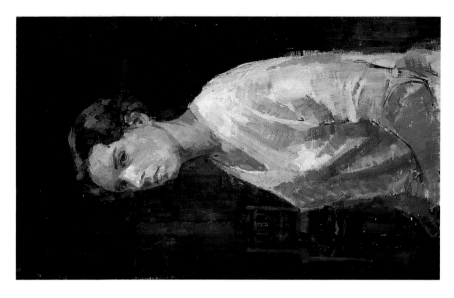

Self-Portrait in John Ward's Studio
Oil on canvas, 1958, 19½x11½in (49.5x29cm)

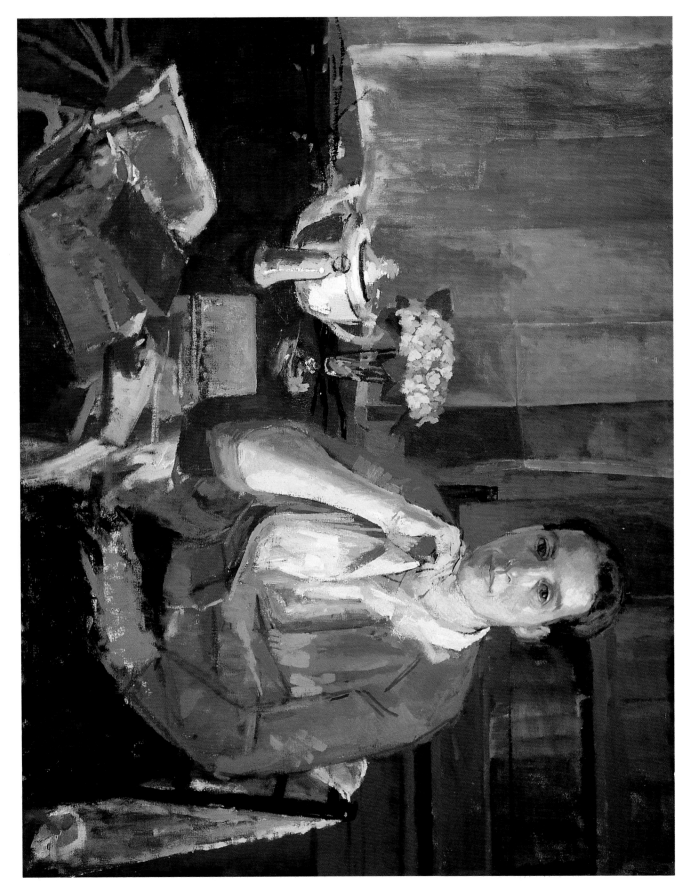

Portrait of My Mother (unfinished)
Oil on canvas, 1959, 27x35in (68.5x89cm)

cadmium red and cadmium green, which give this particular mix of browns and greys and a more muddy, earthy look to the skin colours.'

In the unfinished portrait of her mother at forty, (p.9) the cadmiums feature strongly. The composition is articulated on an heraldic pattern borrowed from John Ward: the canvas is divided into balancing quarters and also balances across the diagonals. With primroses and her favourite books behind her, Mrs Kay sits serene in her world. This key painting was the culmination of two years spent on and off in John Ward's studio and is a pointer to the domestic portraits and still lifes of later years. Physiognomy aside, the *Self-Portrait in John Ward's Studio* (p.8) also reveals a propensity for unadorned observation which is characteristic of the artist's work today.

'From John I learned professionalism: you get in at nine, you work and you don't stop until the end of the day. There was no time to wait for inspiration. At college, there was not the same sense of direction or purposefulness and I felt a bit at sea when I went back there.'

Indeed, the next year we find Pamela making an art school style, imaginative composition entitled *Cockleshell Walk*. She was clearly having difficulty in reconciling the creative demands of some of her teachers with her already stated interest in Naturalism. Today, she thinks this conflict was itself a creative thing: 'When there's no conflict there's no life. As long as there is not a hiatus that cancels out the tensions that are pulling you both ways, then you are fighting your way through this appalling thicket, which is called painting.'

Owing its broken, textural effect to some art student's discarded painting beneath, *Cockleshell Walk* does have the sort of strong, but diversely handled background structure that will be noted in many still-life and garden paintings. The prominent figure, who has the bearing of a contemporary fashion-plate model, was the

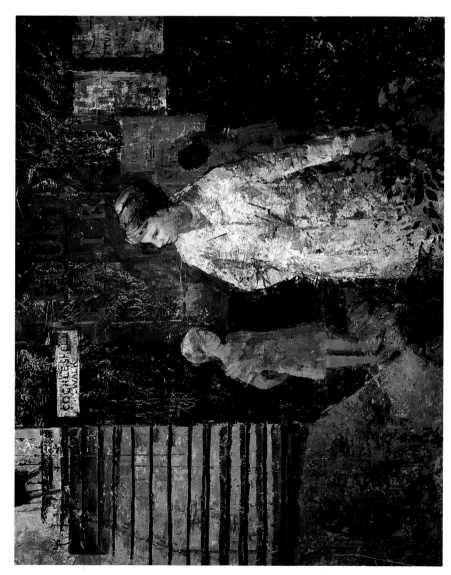

Cockleshell Walk
Oil on board, 1959, 23x29in (58.5x73.5cm) (Exhibited Royal Academy, 1960)

drawing he had already done of a man on a horse, and wanted to go home. It was totally intimidating.

'I fudged about a bit for a couple of days and John could soon see I was getting nowhere. He had been commissioned to illustrate *Cider with Rosie* for Laurie Lee and I ended up modelling for the book. Music would play throughout the day in his enormous studio: Bach's *B Minor Mass*, the *St John Passion*, all the Mozart operas. It was idyllic and a marvellous education. It was like the atelier system: the aspiring apprentice working with a master. I didn't have to mix his colours for

him, nor did I actually work on any of his paintings, but it was teaching by example, which is really the best way.

'In the fierce glow of that kind of talent you need an awful lot of neck to sit down and do something you know is going to be so inferior. But John would make me get up early to do my own work, including the self-portrait in his studio. Curiously, the eyes and the nose in this painting remind me more of John than of me. When you are sitting for someone all day you become very familiar with their face. It is also painted in the palette he was using at the time:

Bill Bowden, Trumpet
Pencil drawing, 1974, 8x5¾in (20x14.5cm)

artist's flat-mate, with whom she shared a haunted medieval tower in Canterbury's Burgate. The encounter itself is set beneath the jetty at Gravesend, close to where Whistler once drew. Yet the real Cockleshell Walk is in Sittingbourne, another Kentish town.

The picture was a success at the Royal Academy Summer Exhibition and on a subsequent tour. But by this time Pamela Kay had other things on her mind. Feeling that she should not emerge from college without a supporting craft that might earn her a living, she tried pottery and then textile design, at which she was an immediate success. She won a Sanderson's wallpaper competition and on the day that she travelled to London for interview at the Royal College of Art, her work was hanging at the Royal Design Centre. Although she earned her living by designing textiles, she never stopped painting, her true mode of expression. She found that the other students at the Royal College took their

design work very seriously and was surprised at how precious they could be about what to her was commercial design.

At this stage, although she continued to exhibit at the Royal Academy, her painting was definitely placed on the back burner. Pamela claims that she was too busy to cast any jealous glances in the direction of the Painting School. Apart from exchanging greetings with David Hockney and his friends in the canteen, she eschewed painters and textile designers for industrial design students, who were mostly male and fond of her spaghetti bolognese.

After graduation she returned to Sheppey to start her freelance practice, producing popular fabric and paper designs in considerable quantities. Their sometimes fanciful, sometimes bold period feel permeated the national consciousness and is still sometimes glimpsed today. One example is the standard-lamp shade in Del and Rodney's flat in the television series *Only Fools and Horses*.

Through Chris Alexander, Pamela met a headmaster called Tony Bryan in September 1963. Within three months they were married, with her former tutor acting as best man. Having been an art student for seven years she had already decided that she would not marry another artist. She believed that in such a marriage the woman was most likely to sacrifice her career. She was also sure that one day she would return to full-time painting. Probably as a result of this ambition, as well as her declared aversion to committing herself to finding work for assistants, she never enlarged her design practice. Nevertheless, it was a time when the textile market was designer-led and successful names like Pamela Kay were in considerable demand.

In 1964 Tony was appointed to a primary school in Ramsgate and they moved to their Edwardian house in the nearby residential district of Cliftonville. That year their first daughter, Victoria, was born, followed by Hannah in 1969. Pamela continued with her design work, as well

as some part-time teaching, while raising the children and fulfilling the obligations of a headmaster's wife. In the recession of the early 1970s the design market slumped and in the shake-out became manufacturer-led, with designers increasingly being told to interpret other people's visuals.

'I then realised that the work was starting to be soul-destroying. You have a short shelf-life as a designer anyway, and the moment that is over you die. This is why designers end up being producers and feed off students, who can see the trends coming. I didn't want that and it seemed time for a change. The girls were growing up and I had more time. So in the mid-1970s I started to pick up the threads of my painting career. The full transition from textiles to painting took almost ten years, but I knew what I wanted to do and was prepared to follow my instincts to be able to achieve it. I had done several portrait drawings of the children, but the quality of my still-life painting went backwards for some while. Not only was I going right back into working right from scratch again, but I was finding my own voice, or my own view in painting. Yet I tried to retain all the good influences and not throw the baby out with the bath water.'

The 1974 sketch-book drawing of *Bill Bowden, Trumpet* shows that even at this time there was no question about the quality of Pamela's draughtsmanship. Made at speed from life, with economy and sureness of line, it captures in a few strokes all the stresses and movement of a jazz trumpeter. Described by the artist as one of England's natural eccentrics and an excellent player, the subject is a member of Les Herbert's Jazz Band.

Later, more polished use of the pencil is found in the fine commissioned drawing of a young girl called Ceri Collins, made in 1982. The artist now steers clear of portrait commissions, probably because she finds it impossible to flatter and only too easy to get a truthful likeness. In a manner

consciously reminiscent of the great portrait drawings of Ingres, she has crafted the finely observed head and outlined in telling, angular strokes the girl's haunting pose.

Although unshaded, each defined area of figure and clothing can be read with absolute credibility as a three-dimensional volume. At the same time the spare arrangement of lines forms the most satisfying abstract pattern. Similar rigour of design will be noted in Pamela's still-life paintings, and her comprehension of the abstract concepts can be ascribed both to the years of practical design work and the ingrained attitude to draughtsmanship. Pamela found the commission a pleasure to undertake:

'Ceri was the most beautiful young girl, I suppose about twelve or thirteen, but she was so fragilely thin. It was so good to be able to draw her and be paid to do so. Once I had really started painting

and drawing again I also started to look for my gods. There was Ingrès, there was Fantin-Latour, there was Chardin and a lot more, but those were the main ones. I have always thought that line could encompass form if it is in the right place. Picasso could achieve that and so can John Ward. You have to be very decisive: nothing can be fudged. It is also important that you draw constantly. If I stop drawing for any length of time, I like to return to it and spend about a week just making drawings. It is quite amazing how that can improve everything you do.'

Five years further on we find the artist making a charcoal drawing of Emma, one of a group of students to whom Pamela had until 1985 been teaching drawing one day a week at the School of Architecture at Canterbury. Over a period of time Pamela made several exquisite paintings and drawings of Emma:

'She needed the money and was a good model, quiet and withdrawn and very beautiful, with lovely colour. The relationship worked well and we even did her washing when she came along to sit for me! I like working with charcoal and you can see that, in the years since doing the drawing of Ceri, the influence of painting had made me become less reliant on pure line.'

Indeed, in the period between the first two drawings Pamela Kay was finding her feet again with her painting. Her mother had taken up painting and had helped to form a small art group on the Isle of Sheppey. Pamela would talk and work with the group and found that in helping them to learn she was aiding her own process of relearning. By 1975 she felt sufficiently advanced in this process to approach John Walters, a member of Les Herbert's Jazz Band, who, as area librarian, ran Margate's newly built library and art gallery, with the suggestion that she might have an exhibition there. She had two extremely successful shows at Margate and two at Deal library, and soon realised that she should venture further afield, probably back to London.

'On one memorable car journey I decided on three objectives: I wanted to write for *The Artist* magazine, to become a member of the Royal Watercolour Society and to have a London exhibition. I wrote to the editor of *The Artist*, and ended up writing a series for its stable-mate *Leisure Painter.* Having been told all about the RWS by John Ward, I applied unsuccessfully for membership in 1982, with the support of Ernest Greenwood, the President. I started getting work into the exhibitions of the Royal Society of British Artists and the New English Art Club. In 1983 I was elected to the RWS and the RBA and had a show in London at the Medici Gallery, which had approached me. Being elected to the RWS was absolutely marvellous, and has continued to be. The discipline of two shows each year, among good company, at a prestigious London gallery is about as much as an artist can ask for.

'Always having that wall to show on is very important, especially if you have any sort of following. The first year I didn't get a picture into the Academy a lovely lady working in the cloakroom said to me "I'm so sorry you weren't in this year." I thought, "I didn't even know you went and looked at my paintings." So exhibiting is not something you can take or leave: there really is an obligation to do so. There are people who want to see what you have been doing, even if it's only to say "Ah, it's not as good as last time; let's see if she does better next time!" Or there will be painters who will come and say, "That's not very good. I could do better than that", which is much better than saying "Oh, I could never do anything like that", which I find very dispiriting. The whole point is to encourage people, not to let them feel put down by other people's excellence, but to attempt to rise to it.

After her well-received Medici Gallery exhibition, Pamela went on to hold further highly acclaimed one-woman shows at the Richard Hagen Gallery at Broadway, at the Chris Beetles Gallery in London's Ryder Street, and more re-

Emma
Charcoal drawing, 1987, 17x11½in (43x29cm)

cently at the Catto Gallery in Hampstead, where she has gone from success to success. A prolific and enormously hard-working painter, she found that the revival of her own art coincided with a boom in the collecting of paintings for private homes, from which she benefited considerably. The professionalism Pamela had observed in John Ward's studio, and experience gained selling textile designs, were applied to servicing this demand.

When in 1984 Tony took early retirement, he was able to lend his further support to Pamela's career, while also providing his professional resources as office administrator and photographer to the partnership. She is not shy of admitting to considerable business acumen, believing that successful painters of past centuries must have required such an attitude. While confessing to moments of magic, she feels that they do not come unbidden and rejects the myth that the artist can only do anything when the spirit moves him or her. Pamela is acutely aware that her husband's support in allowing her to become the bread-winner was crucial to her career as a painter. She is profoundly conscious of the difficulties other women painters undergo and of how few are allowed or allow themselves to put their talents into action. She becomes angry when she hears from amateur artists that, constrained by their day-time jobs or their household, they cannot make time or room to paint. She tells them that they *must* make time and room.

By the mid-1980s the business of painting was in full swing and the quality of Pamela's paintings – still life, portraits, landscape and interiors – was hitting those peaks we come to take for granted today. Not only does she organise her own practice professionally, but she also relies on a back-up team of professionals in their own fields. These include the obvious mount cutters, framers, galleries. They also include the invaluable services of her local baker, *patissier*, florist and greengrocer, who supply her subject matter. However, choosing the right subject matter is not simply an ad hoc affair, as Pamela explains:

'Tom, the greengrocer, whose shop is just beyond the bottom of the garden, will get things from the market for me, for example. Before it became easy to get fruit out of season, he was finding me cherries in January. I had to pay dearly for them, but I could get them, and it was cheaper than going up to Fortnum's. Fruit is usually inedible by the time I have finished with it, and sometimes before. It's an occupational hazard. Although I occasionally keep bread for a while, it nearly always shrinks.

'One time I bought some bread-rolls for a picture and left them on the kitchen table. The girls came in from school and ate them. I was very cross, although I shouldn't have been because the poor souls were hungry. But I did read them the riot act, so now they tend to ask whether food is for eating or for painting before they dive in! So another occupational hazard is that you have to watch out in case people eat your subject.'

More durable subject matter, such as pieces of old china, has accumulated in considerable amounts. A renewable source of subject matter is the artist's much-loved paved back garden. Trial and error has led to the creation of a varied, constantly changing display. In some thirty years of what Pamela describes as 'dedicated neglect', mature bushes and roses have become established, making the garden a haven of tranquillity. The paving gives her maximum versatility in re-arranging her many pot-plants to make compositions. Pamela Kay's garden paintings are an example of how her art has been enriched and has continued to develop since the mid-1980s:

'Painting a garden is a matter of bringing order out of chaos – something, if I may generalise, I think women do better than men. You can be totally overwhelmed at first by the wealth of detail and incident – just the number of leaves, for goodness sake! It's a question of getting the flavour of the thing, without being overcome by it. I found I could not pitch straight into large

Ceri Collins
Conté pencil drawing, 1982, 25×20in (63.5×51cm)

canvases, but had to build up with series of small oils on board, which I still continue with. But now I believe I have got to grips with the subject and can be pleased with the larger picture. Get to know your friends and then like them better. It's much the same with painting.'

However intuitive her understanding of the subject may become, Pamela's approach to the craft of painting is characteristically professional. She knows, for example, precisely how she sets about a garden watercolour:

'I start off drawing, not with a pencil but with a well-pointed brush and very pale ultramarine blue, so that I know where things are going to go. Then I put on large masses of thin pale wash to plot the massed areas of tone – rather like sketching a map. I isolate the light areas that I don't wish to touch too much, like flower-heads, and will put in some detail if appropriate. Then I start looking for the lights and the darks, starting with the darkest parts, where I will do quite a bit of brush-drawing, building them up layer upon layer, a bit like a tapestry. Then I work up to the lighter tones, which with experience becomes an intuitive process. If I find, when I get there, that I have lost the light, either by making it too dark or by missing an area that should have been light, I will use opaque body-colour or gouache. I believe in having my cake and eating it: I am in charge, so if I want it white I shall put it in opaque if I've missed it as transparent. I don't believe in rules. If people say you should always leave the paper white, I say, "Well, if I don't that's too bad, I shall put some white on". In the end what matters is that you get what you want.

'With an oil painting the approach is not entirely dissimilar. First I lay on colour wash that approximates to the eventual background colour, both because white canvas usually seems too nasty to work on and because it gives a unifying colour cast underneath the whole picture. I then draw in approximate colour areas, then go on drawing more and more, assessing the colour and tone as I go. This should be a gradual process that happens all over the canvas until it gets sufficiently close to the right pitch of tone and colour. At this point I will concentrate on finishing one area, perhaps a jam tart or a lemon, which will be the key to the painting. I can then work up everything else round that key.

'For small oils I will use a board, which is very responsive, although for larger works only a canvas is practical. I have never been frightened of an empty canvas, because I know I always have all the options. No technique should be so demanding, so dogmatic, that it becomes inhibiting or gets in the way of being able to change your mind, experiment and make discoveries. Before I start, the palette, the turps and about thirty brushes are all clean. I lay out my palette more or less as I did when I was a student. I think I have only added one colour in the last fifteen years; a pretty rash decision!

'My watercolour palette has a slightly different range of colours and is laid out in the opposite direction on a white dinner-plate. I always keep the white body-colour on a separate plate so that the opaque mixes which I use for drawing don't interfere with the transparent mixes for washes. Generally I can get my mixes with a very limited range of colours. If I don't get the right paper for a watercolour, the painting dies on me. I went through a terrible time after the mill that made the paper I had always used burnt down. Eventually I started using Saunders Waterford, which was the nearest I could get to my old paper.'

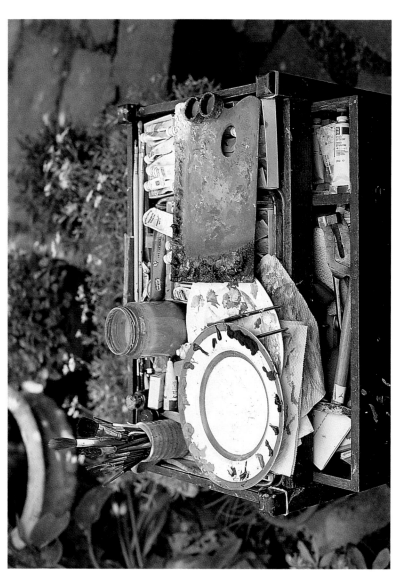

Pamela Kay's Palette
Photograph, 1992

FAMILY

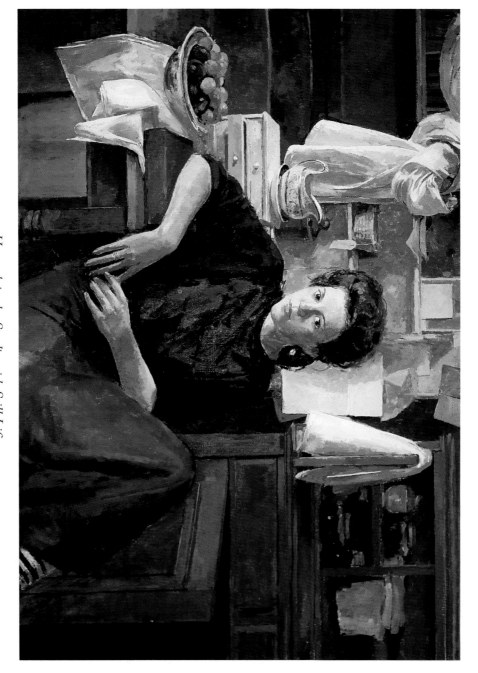

Hannah in the Studio with Still Life
Oil on canvas, 1987, 30x40in (76x101.5cm)

Much of Pamela Kay's portraiture depicts members of her family, in particular her two daughters, Victoria and Hannah. This substantial canvas of Hannah was painted while, like her mother before her, she was a student at Canterbury College of Art. An intent but relaxed portrait, the dark and simply clad shape of the figure is surrounded by a prominently lit group of the artist's still-life accoutrements. The artist is clearly concerned with harmonising the sitter within the studio environment.

'I am only really happy when I work in my own studio, rather than in anyone else's space, but I don't like having intruders in my studio! With the family I can relax and usually get a good painting. One person doesn't demand too much of the other, because you both know what you have to give, and that understanding helps it to work.'

If Hannah was well integrated into a still life in the last canvas, the artist here places herself in a position subservient to an array of cherished props and her participation is really emblematic. She has said that all pictures are akin to self-portraits. Thus her paintings of objects gathered over a life-time survey that life, and the slightness of her own presence does not matter. Here she also pays homage to some of her masters: to Chardin via two postcards of paintings in the Hunterian Art Gallery, to Fantin-Latour, to Monet, whose painting of *The Luncheon* from the Musée d'Orsay hangs cock-eyed at the top of the picture, and to Vuillard:

'I painted this after seeing the great Vuillard exhibition in Glasgow. It is said he is a painter's painter, and he particularly made me look again at the presence of colour in neutral colours, like grey.'

———

About a year after the canvas of Hannah was completed, the artist embarked on this portrait, its equally ambitious partner. The effect of the girl's red hair against the well-articulated areas of white cloth and neutral greys is quite stunning. Pamela explains how she achieved this:

'This was Hannah's Swan Vesta period, when she had her hair bleached and then dyed this fantastic orange colour, which looked superb against her lovely white skin. I had been to Sandwich, to the garden of Ann Swanton, wife of the cricket writer E. W. Swanton, and brought back all these lilies. The stamens were the same colour as Hannah's hair, so there was this lovely flick of orange in the flowers.

'In composing this picture, I was thinking about Dutch old-master flower paintings: the zigzag composition set against the verticals was a conscious influence, as was the placing of the flowers in a square niche in the top right-hand corner.'

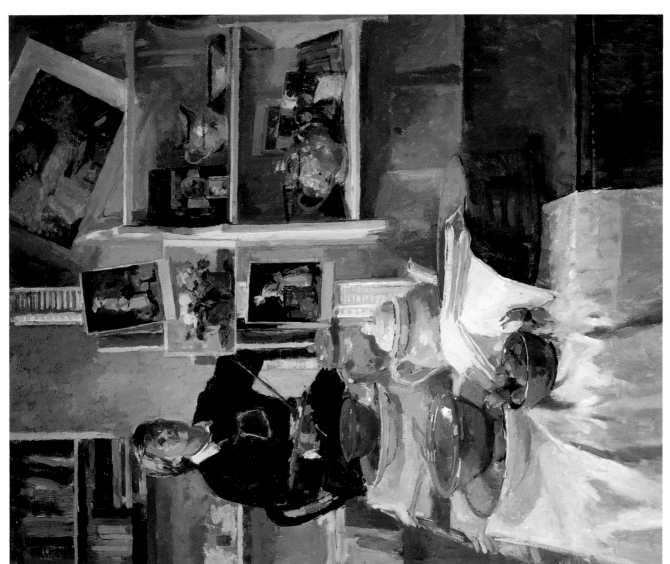

Self-Portrait with Still Life
Oil on canvas, 1991, 24x20in (61x51cm)

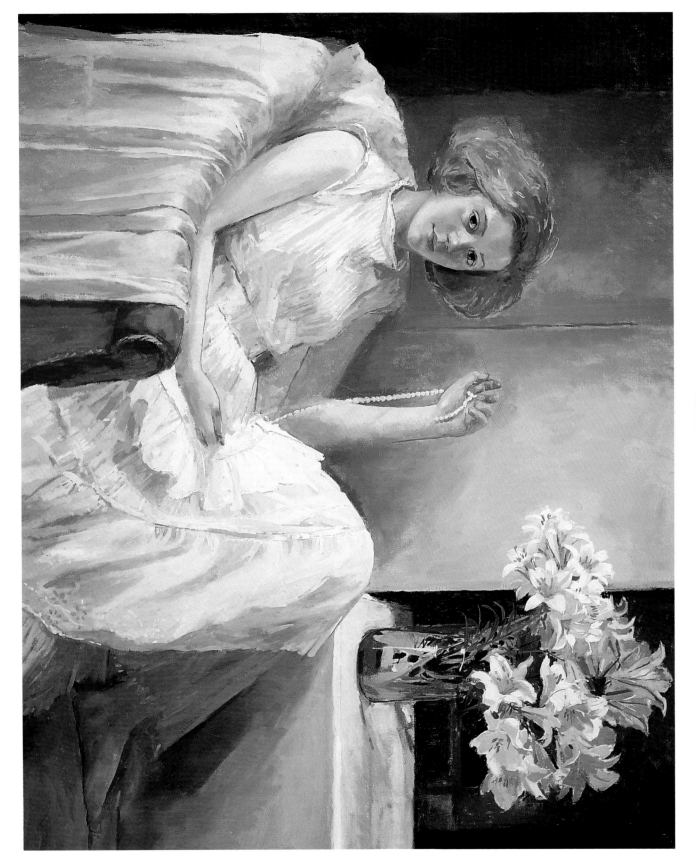

Hannah and Ann Swanton's Lilies
Oil on canvas, 1988, 30x40in (76x101.5cm)

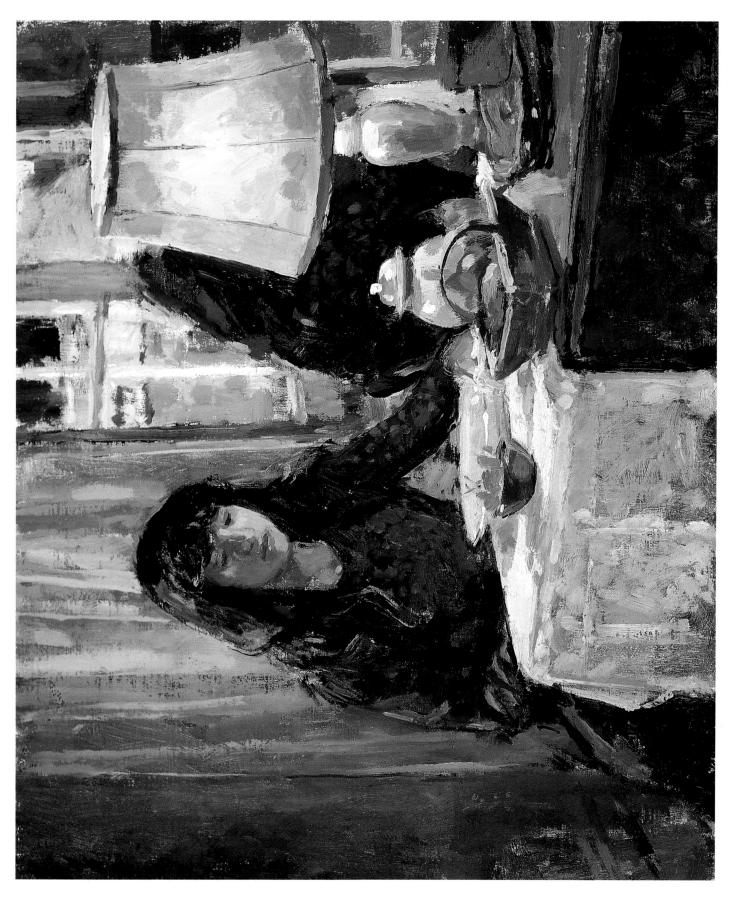

Victoria by the Studio Mirror
Oil on board, 1991, 10x12in (25.5x30.5cm)

J

Good portraits are often, but not exclusively about the sitters, and this ambitious canvas is clearly about Victoria. But all good painting is about painting, about its aesthetics and its craft, and good portraits are not excluded from this law.

Differing motivations seem to lie behind these two paintings of the artist's daughter Victoria. The informal, freely brushed study on board uses her as a model, reflected in a mirror as the central focus of the composition. But she is just that: part of the arrangement, not a closely observed sitter. The study is about tonal changes and effects of light and colour: the variation between the warm light of the lamp and the cool blue light on the tablecloth is precisely transcribed.

At first sight the large full-length canvas is primarily a portrait. The sitter's features have been carefully detailed: a likeness has been achieved. The full-length format, unusual in this collection of work, but one to be seen in some earlier pictures of Pamela's family, echoes a tradition going back through Whistler to Van Dyck. Revelling in the colours and textures of fabrics, Van Dyck combined blacks, reds and golds to great effect. Mention of Whistler brings to mind studies in colour harmonies juxtaposing colours and 'non-colours', in pictures such as *Symphony in White No 1: The White Girl* in Washington and the Goya-like *Red and Black: The Fan: Mrs Charles Whibley* in the Hunterian. Whistler was not averse to making a feature of the plunging perspective that the painter working close up to a sitter truly sees, and nor has Pamela Kay wished or been able to disguise this in the drawing of her daughter's legs and feet.

'You really need a good run back to be able to paint a canvas this size. In an ideal world a tennis court-sized studio would be about right. Mine is really quite small, so this was a very difficult painting to do. It's more of a vertical panorama really, observed bit by bit. At the end, you hope it all connects up and you haven't missed any bits out. The colouring is very much a part of Victoria's character: strong, rich reds and emphatic blacks. Hannah, on the other hand, is more subtle, with the odd surprise, as is the colouring in her portraits.'

Victoria – Full-length Portrait
Oil on canvas, 1992, 60x24in (152.5x61cm)

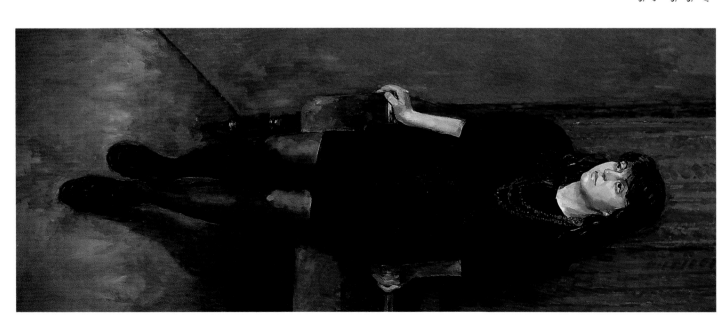

TRAVELS AND INTERIORS

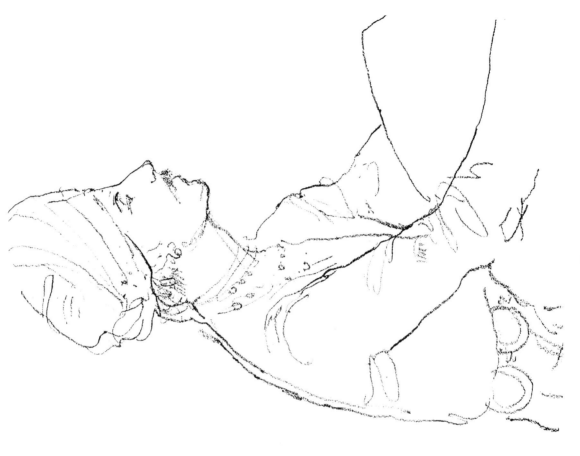

Dancer, Jaisalmer, India
Pencil drawing, 1990, 9¾x7¼in (24.5x18.5cm)

I n recent years Pamela Kay has managed to take one or two breaks per year from her studio-bound regime and has travelled widely. Usually, however, this has been to work. Italy has provided fruitful subjects for a series of architectural *plein-air* watercolours, together with oil paintings of restaurant scenes, which perhaps fit more consistently with the artist's overall oeuvre. Further afield, Pamela has travelled to Russia, Egypt and India:

'Tony lectured at the Indian Military Academy during World War II and had always wanted to return. I don't like being ill and I can't bear roughing it, because I have already done all that. The only way I was going to visit India was five-star, if we could afford it. So, to celebrate our silver wedding anniversary, we went on a Swan Hellenic tour, with a wonderful lecturer, Professor Adrian Mayer, formerly of the School of Oriental and African Studies in London. It was the most thrilling trip.

'This drawing was made out in the desert at Jaisalmer, about three days into the tour. That night we were entertained by a local troupe of dancers and musicians. It was one of the most exciting things I've ever experienced. This was the male dancer, who was actually extremely feminine: there was a clear ambivalence. Interestingly, it was the young girl dancer who was organising the whole show and was clearly in charge of him and the three male musicians. But he was a brilliant dancer, was gorgeously dressed, had a wonderful profile and absolutely adored being drawn.

'I had to do this in a few minutes because his head was moving. He was continually turning to chat to the girl next to him, so I had to draw,

remember, then carry on drawing somewhere else while I waited for his head to come back. I just couldn't stop drawing throughout the performance and worked at terrific speed, with a fervour and intensity that you can only have at the time. You cannot take photographs and then expect to get a drawing out of them. It's like a friend of mine said: "If you've done a painting in the snow, it should look as if you've been frozen to death." If you've had a thrilling experience in India, then it should come out of the drawings. It should vibrate off them. I can still hear the drums!'

As in the drawing of Ceri Collins, it can be seen how a few, correctly placed lines are capable of wrapping up form, volume and character. This sort of economy of expression is only won via the constant practice of drawing that the artist describes. Indeed, the two attempts at the correct line of this dancer's back are evidence of the continual refinement of seeing that drawing affords the enquiring and the dedicated artist.

The study of two Japanese tourists munching their breakfast on the north side of St Mark's is less spare and more a considered arrangement, finding amusement in the juxtaposition of marble lion and humans. The pencil is wielded with a flourish, happily capturing the movement of hands and arms with what ought logically to be an incomprehensible jumble of florid lines. Pamela explains how the drawing came about:

'I went to Venice for a week just to make drawings. I was always up early in the morning and one day was drawing these red marble lions, which, as you can see, people tend to climb over, when this lovely Japanese couple sat down to breakfast, looking sheepish and slightly embarrassed. So I drew them as well. I like to incorporate people in my drawings of Venetian architecture, but this is more like reportage.'

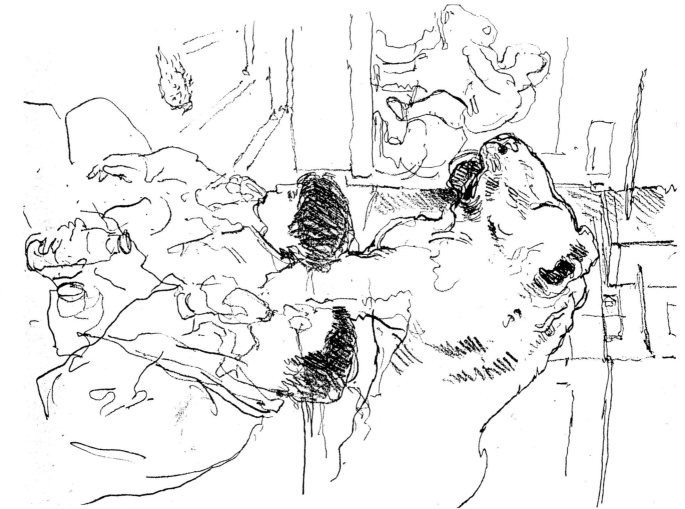

Japanese at Breakfast in the Piazza, Venice
Pencil drawing, 1991, 10x7¼in (25.5x18.5cm)

On her European excursions Pamela has not allowed her work to get in the way of her appreciation of good food. The interiors of Venetian, Sianese and Parisian restaurants that follow show that she has managed to combine the two. An early and English example of this gastronomic genre is this pencil study for an oil painting of the restaurant in the Assembly Rooms, Bath, made while the Royal Watercolour Society was exhibiting at the city's Contemporary Art Fair, then held in this elegant Georgian building, in which it is reputed that Jane Austen once danced.

'In the early 1980s I used to study the work of Bernard Dunstan very closely. He is really a son of Vuillard, Bonnard and Sickert, working in a proper tradition, and I knew that if I tried to follow his method I wouldn't go too far wrong. He would work with a sketch-book, making colour notes, and then return to the studio to paint, using these notes and his excellent memory recall. He might also take photographs, but using them like the Post-Impressionists did, as an aide-memoire only. It was too dark to take photographs in this restaurant, so all I had was this sketch-book page, which owes a lot to that study of Bernard's work, his book and articles.'

The watercolour of *Le Frégate* was made in the studio from similar colour notes and from a watercolour sketch done on the spot. The Seine-side restaurant was discovered on a visit to the newly opened Musée d'Orsay, as Pamela explains:

'Although the prices were rather intimidating, we went in to find it was a real *fin de siècle* restaurant; everything I thought Paris should be. It had a zinc counter with beautiful fitments, bent-wood chairs, maroon plush *banquettes* and walls the colour of nicotine with wonderful mouldings and cornices. And there was this stunning marble-topped pudding table.

Le Frégate was run by a woman in a grey suit

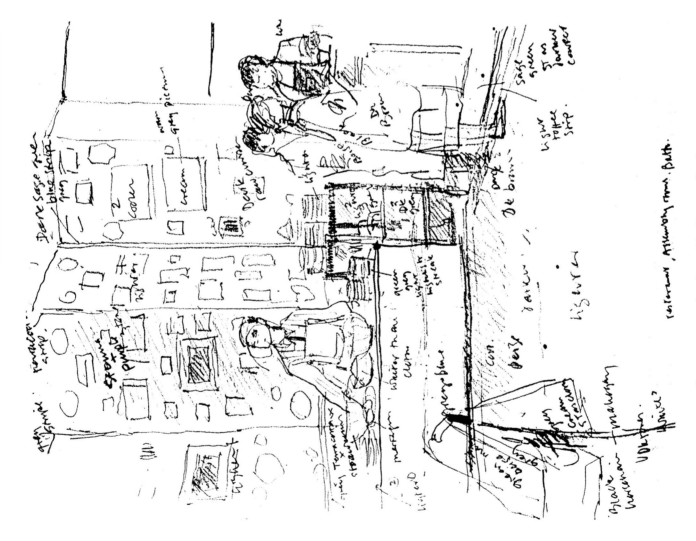

Restaurant in the Assembly Rooms, Bath
Pencil drawing, 1984, 9¼x7¼in (24x18.5cm)

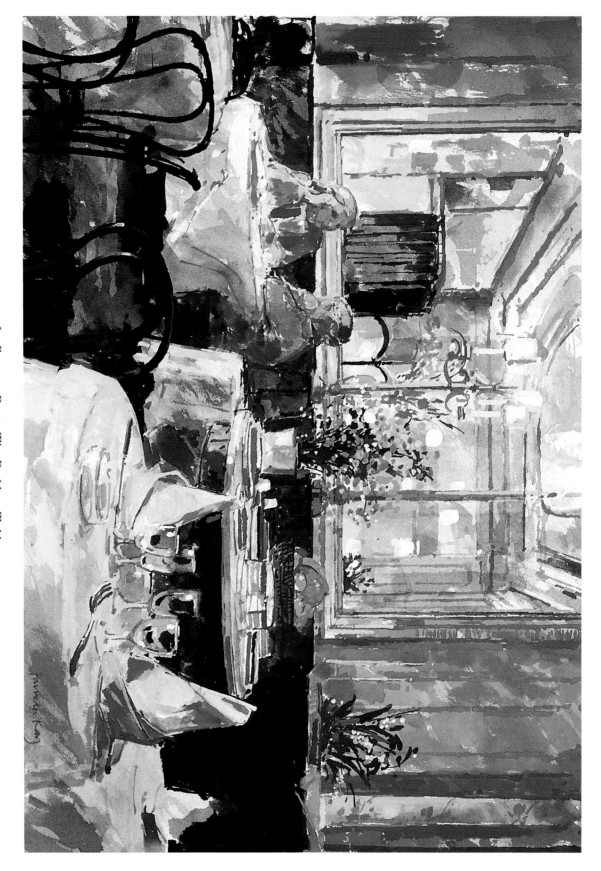

Le Frégate, Paris, The Pudding Table
Watercolour, 1987, 13½x20¼in (34x51.5cm)

with an Eton crop, who looked at first sight as though she would have made a good prison-camp guard. She was *formidable*; one of those women the word was made for. We went in three or four times during our stay and I would

draw and make colour notes. On the last day the woman with the Eton crop came over to look and suddenly became human. She was absolutely entranced and charming: it was like Jekyll and Hyde.

'When we went back a few years later we were heartbroken, because new owners had ripped everything out and pushed the prices further up, and of course the woman was gone.'

23

'Montin's is in Dorsoduro, round the back of the Accademia, and is something of an artists' and writers' club. Ezra Pound and Modigliani, for example, were once regulars. The food has always been good, although legend has it that the chef is temperamental! But the nicest thing about the place is the proprietor, who looks like a cross between Omar Sharif and Danny La Rue. He is absolutely wonderful and he knows he's wonderful. He more or less demands to be drawn and then demands the drawing for the ever-growing collection of pictures.'

On the opposite page of Pamela's sketch-book from the compositional study are colour and tone notes, referring in detail to each area of the study. These were sufficient indicators of the limited ranges of colour and tone to be seen in a restaurant in subdued winter light to enable her to re-create the scene in oil back in the studio, with the feel of a painting made on the spot. The atmosphere of a traditional Venetian hostelry has been caught and conveyed as if it were bottled. The un-yielding surface of the board gives immediacy and vitality to the brush-work, which helps to affirm this impression, as does the varied state of finish from foreground to background, which also serves to emphasise the strong perspective of the tables.

We may note that there are differences between the character of Pamela Kay's work on canvas and on board as great as those between her work in oils and in watercolours. The type of painting board used was another lesson learned from Bernard Dunstan's work, as Pamela explains:

'The surface is made from cotton bed-sheets, which my father ferrets out from car-boot sales and other places. These I put down onto hardboard with rabbit-skin glue size. On top of that go two or three very thin layers of a carefully prepared emulsion of egg, water and linseed oil, mixed first with titanium white powder to make a

paste and then thinned to the consistency of single cream with glue size. I then finish off with another thin coat of glue size to seal the surface. I like to keep to natural products, because you don't know how synthetic ones are going to react in the future. If I am going to paint a picture it has to last, and in any case I don't find the quality of factory-made boards to my liking.'

LEFT
Interior, Montin's – Venice
Pencil drawing, 1989, 11½x8½in (29x21.5cm)

RIGHT
Interior, Montin's – Venice
Oil on board, 1989, 11x9in (28x23cm)

'The *Osteria Le Logge* is a former apothecary's shop near the Campo in the middle of Siena and is run by an amazing chef with a beard, who is the big selling point. Americans love the place and it is fully booked the whole time. For me, the real appeal was being surrounded by some of the things I most love to paint. There are huge cupboards all round the walls, full of glasses and bottles. There were racks at the back with tarts and salads waiting, and piles of plates. There was this lovely table in front of the doorway which made a beautiful composition.

'I did a lot of drawings there so that I got to be very familiar with the colour, which was fairly subdued. I then painted the picture back in the studio, which was pretty straightforward. But when I was working in Florian's I was sitting on one of their *banquettes* next to a very extrovert German family having a birthday tea. They kept bouncing up and down in excitement, so I had a very shaky hand. You get a rather sensitive, very nervous line that way.

'The left half of the painting of Florian's was done from a watercolour reference and the right half from a pencil drawing. I simply reconstructed the scene when I returned to the studio. While I was there I worked on whatever I could as simply and discreetly as possible, partly because I always try very hard not to leave any stains or mess. Once you do something disastrous it just wrecks it for other painters. Apart from that you might find there are people who don't wish to be drawn, so you shouldn't be intrusive.

'I like to cultivate the art of being invisible, which for an artist drawing in a public place in Italy is pretty difficult. Of course, the waiters at Florian's are all very blasé about artists, which they get ten-a-penny, including royalty. The only trouble is that you pay such a high rent for the space. But that does work to my advantage, because in the Italian custom everyone else sits there for a long time, getting their value for money. So I get excellent models!'

Osteria Le Logge – Siena
Oil on board, 1990, 11x10in (28x25.5cm)

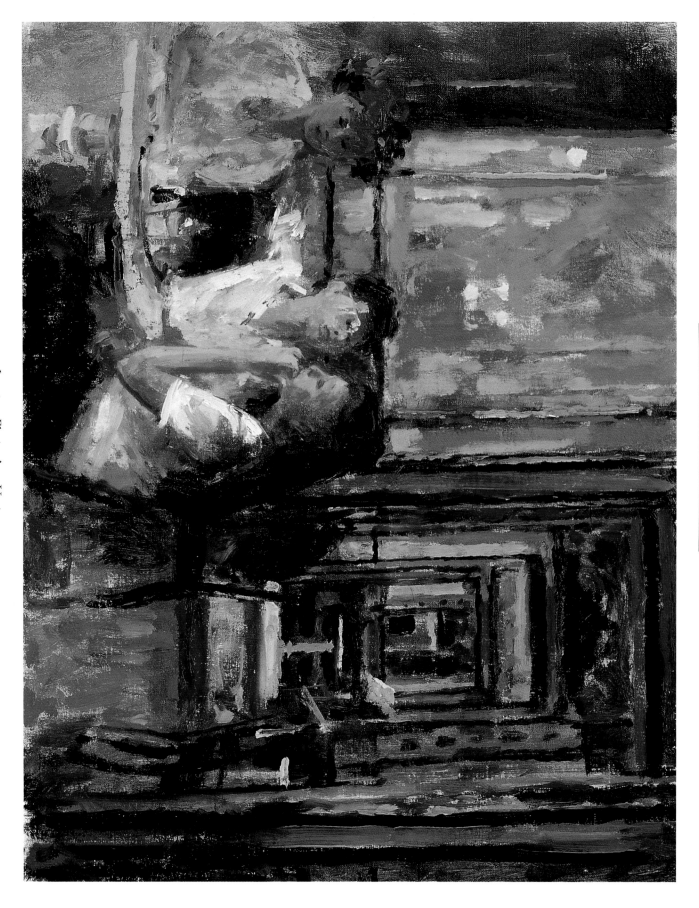

Interior, Florian's – Venice
Oil on board, 1989, 10x13in (25.5x33cm)

27

Back in the artist's studio a model poses before a mirror. The medium is pastel, often the choice of artists such as Degas, Vuillard and Sickert. When used today, pastel is frequently employed in a manner dictated by this Post-Impressionist to Camden Town School tradition, often relying as it does on the medium's subtle intimacy and soft textures. Combining it with charcoal on a toned paper, Pamela is able here to give the pastel a more structured, linear feel than is sometimes seen. Her keenest interest, however, is in the play of light across a strong composition. The tonal changes are more satisfying than in some equivalent works, with dramatic changes from the model's shoulders to her silhouetted head and the lamp beyond.

'Although pastels take less time than oil paintings, I still find pastels a touch crude and like to draw with them rather than put in dabs of colour. A marvellous thing about Vuillard's work is that it is often not easily possible to distinguish what medium he was using. His oil is like his distemper, which in turn is like his pastel. He used them all with the same hand. Now that shows genius. You can tell the difference between my oils and watercolours, but not his.'

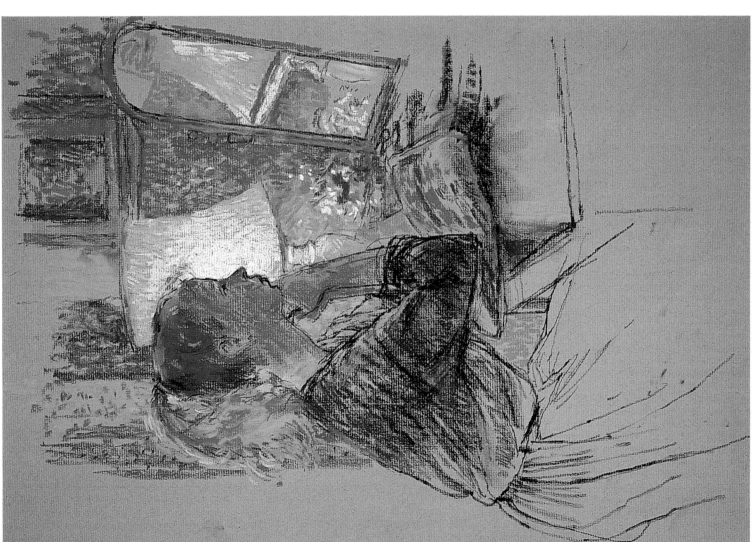

Helen, by a Mirror, Chin on Hands
Pastel and charcoal drawing, 1988,
19x12in (48x30.5cm)

Set up in the artist's house, this small private view of someone at work behind an open door is very much in the Intimiste tradition of Bonnard and Vuillard. Carried to England by Francophiles like Sickert and Gilman, the tradition lives on in the works of Bernard Dunstan and others. Often the controlled surroundings of such a scene are used to arrange a satisfying composition and light effect in the manner akin to that of the still-life painter. Pamela Kay:

'This is our small workroom at the back of the house, with a model and a tailor's dummy. It was taken from a high viewpoint on the stairs: the house has seven different levels and it was nice to be able to work out an unusual composition with dramatic lighting. It was one of my first stabs at interiors with figures, which I think remains as big a field to be explored as I have found the garden to be.

'I find the domestic subject of great interest. For me the home is the centre of the universe. If you have a strong centre, you are all right. When women get to my age they play a sort of role as the guardian of the culture and the home is where that culture can be enshrined to be made available to the next generation. At my time of life there is a danger of petrifaction. I don't actually want to be turned to stone, but I do want to hold onto the things that are eternal, and I think in a sense still life is a way of doing this.'

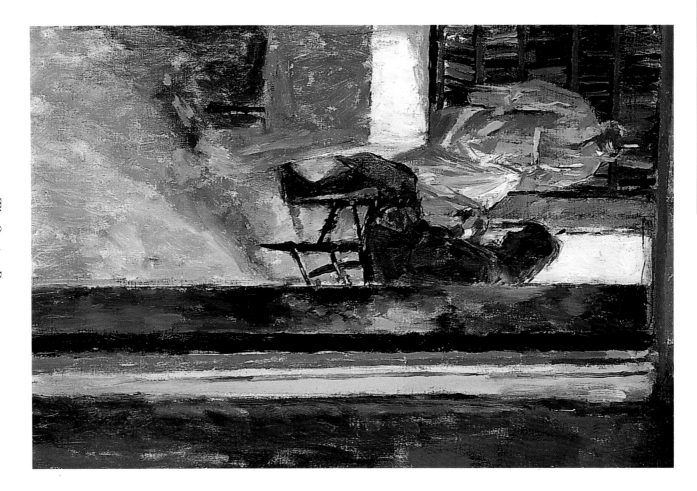

The Sewing Room
Oil on board, 1988, 12x8in (30.5x20cm)

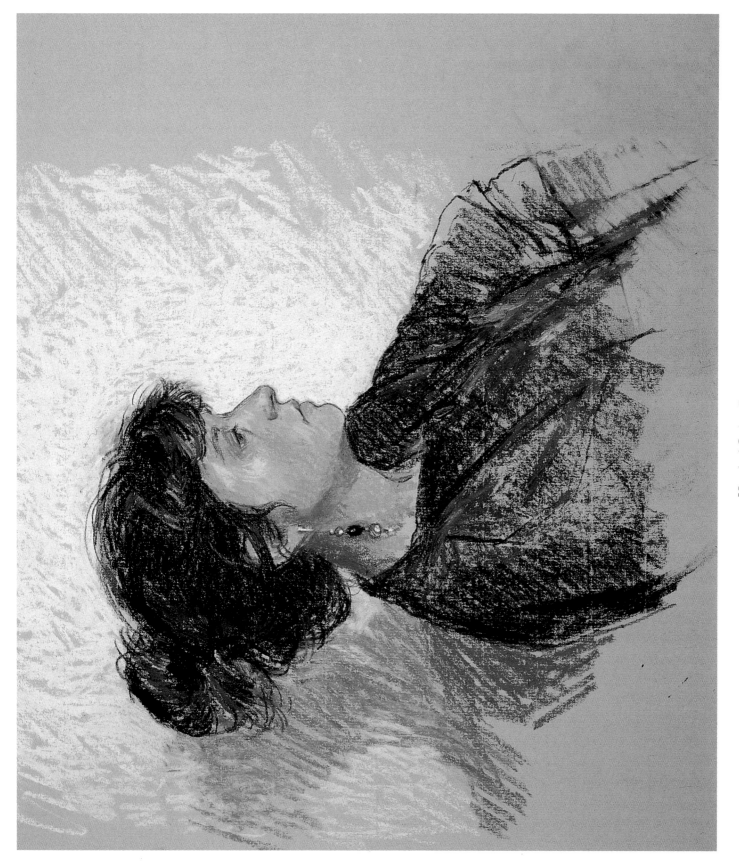

Head of Girl in Profile
Pastel drawing, 1992, 14x12in (35.5x30.5cm)

This second of the artist's fairly infrequent pastels was made some four years after the first. Instead of charcoal the artist has here used pastel for the substantial areas of black drawing. Consistent with her more recent work, the confidently applied passages of black are applied less for linear structure and as a shift in tone, but as strong, simple colour shapes. 'Non-colour' it may be, but as used by a string of great and good artists from Titian and Rubens onwards, black can be made to sing, thanks to its handling and its juxtaposition with more conventional colours.

What is perhaps remarkable about this work is that the principal 'colour' against which the black is revealed is, of course, white, and only the skin colour and touches of blue and mauve are present to offset the richness of the black. This colourist's juxtaposition of white and black is a skill given to painters like Goya and Renoir, but not to everyone. But this interest in colour should not obscure our pleasure in the exquisite draughtsmanship that lies at the heart of this work, and which the artist herself recognises:

'There is nothing more satisfying than a drawing that goes well, and this one seemed to work. It is much more a drawing with pastel than an attempt to make a full-blown picture in the medium. More to do with silhouette and shape, it is, above all else, a demonstration of how lovely it is simply to enjoy drawing just for the sheer pleasure of it.'

The study of the model in oil (above right) concerns itself far more with questions of tonal change and effects of light. Beautifully fluid brush-work ripples across the surface of the board, although its quality apparently stems from the artist's rush to finish the piece in one sitting.

'There is a tyranny of urgency to painting the model. Unlike a still life she moves and breathes and is going to get up and go home and there is always the feeling at the back of your mind that she

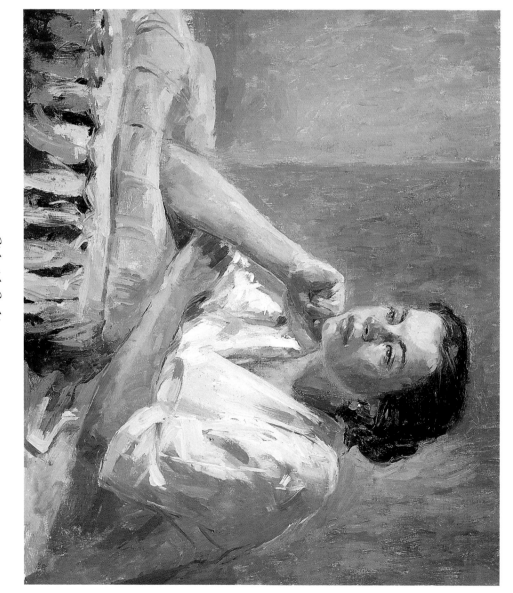

Girl with Cushion
Oil on board, 1991, 12x14in (30.5x35.5cm)

may never come back. What I think informs the brush-work is the speed, the need to make a decision and the need to have the courage to make changes in the knowledge that you might not be able to get it done. Fear makes it, I think, a rather nervous bit of work and that is what gives it life. The same can be true of garden paintings. It is hard to inject that flavour into a still life, difficult to make it appear, and nor indeed should it. 'The model is a lovely Sicilian girl, who makes a

marvellous model and holds long poses absolutely still. She is very sympathetic to the idea of modelling and enters into the spirit of it. She can change her appearance and look older or younger, depending on how she wears her hair, which is very helpful. Her mother runs a restaurant and apparently they talk about food the whole time. The whole business of the family is very strong with her and everything I love about Italy, she *lives*!'

Psychologically, the feeling I was widening my horizons was important. It was also a challenge, because getting the light and tones right was vital. That is true, but it is somehow more true with an interior, because the lighting is very complex.'

Neither the interior nor the exterior light come from very powerful sources. There is no strong sunlight to bleach out the electric source and a real, subtle balance is achieved. The casual observer is only conscious of the sophistication with which the lighting is painted in that he or she is not conscious that it looks wrong.

A development from the previous picture, the theme right moves from the still life, viewed from one step removed, to an elaborate arrangement designed to fill the canvas.

'This is on a much larger format and the garden can be seen through the conservatory windows. The lighting is here more complex and very sparkly, and controlling that was crucial. It really surprised me that the highlights from the right were orange. I like the change from the outside to the inside: from the soft beige, pink and mushroom colours of the garden to the cool, sharper focussed light inside the studio. Even the handling of the paint has to change accordingly. It was a complicated painting, and while it was set up in the studio I couldn't work on anything else, and we ran out of knives and forks!

'The subject is the preparing of the table for a celebration meal near Christmas. Large, extended family meals were something we once had a lot of in the studio. Smaller occasions like this we still do and are very special.'

The very domestic, family-oriented subject emphasises that this room, dedicated as it is to studio use, is the original dining room of an Edwardian, end-of-terrace house. Few artists have the luxury of a purpose-built studio.

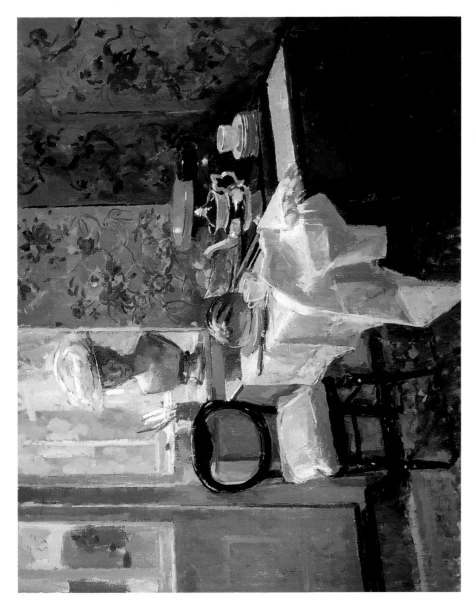

Still-Life Table in the Studio
Oil on canvas, 1991, 18x22in (45.5x56cm)

This canvas shows the corner of Pamela Kay's studio where most of her paintings of still life and flowers are set. The artist has stepped back from her drop-leaf table and drawn into the picture the surroundings in which she habitually works. We can thus see how critical is the placing of the table in relation to the light sources. A cool north light comes in over the garden, bathing the tablecloth. This is balanced by a warmer electric light behind the artist's right shoulder, striking objects such as the brown-glazed jug. The table is sheltered in the even richer reflected light of the background screen. Covered in more subdued material, this is the same screen we see in many of her still-life paintings. Here we are presented with its recent accretion of a hand-made Sanderson floral wallpaper. The reverse has a Sanderson William Morris pattern in soft tonal greens, which appear in one or two of the later paintings. Pamela Kay:

'With this painting and the study that I made for it, I felt I was unchaining myself from my corner in the studio and actually moving back a bit.

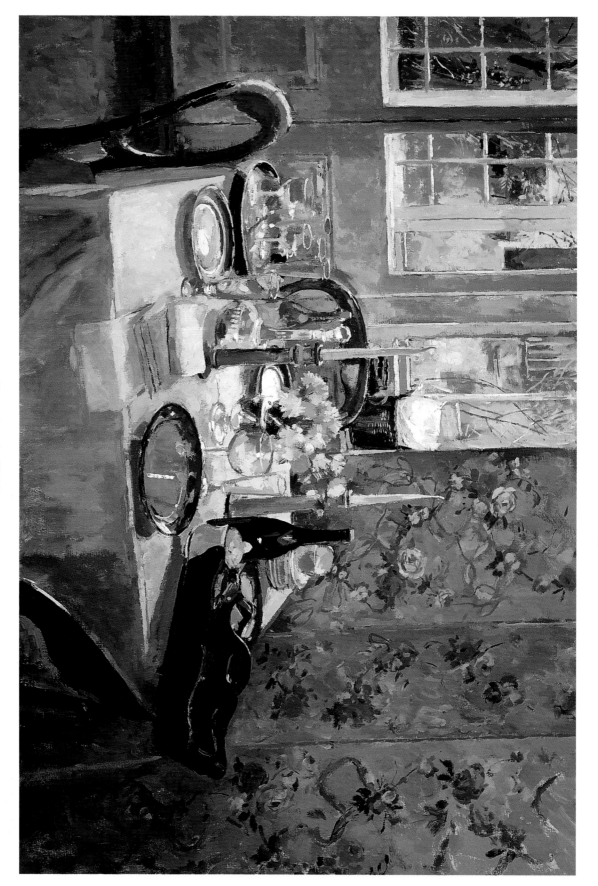

Preparing the Table
Oil on canvas, 1992, 20x30in (51x76cm)

CUPBOARDS

Painted in January 1987, this is the first of an extensive series of paintings of cupboards. As the series has progressed, so new cupboards and many new arrangements of objects have appeared. Pamela explains how the idea originated:

'John Walters, the area librarian who gave me that crucial first exhibition, came into the studio one day. Seeing the cupboard open and revealing all my still-life crockery, he remarked that it would be good to paint. That opened my eyes and I thought he was dead right. I added a still life on the top, opened the doors and got cracking with this picture, which virtually painted itself.

'The final arrangement was partly inspired by a marvellous Chardin in the Louvre, called *The Butler's Table* (1763). On top of the table are a terrine and napkin, a tureen, two decanters, some preserves and a plate standing on its edge at the back, making a beautiful circle of light. The arrangement on the top of the cupboard is very similar. I took a Victorian meat plate with a beautiful blue colour and then arranged my own still life with a small tureen, some preserves and some dishes. To break up the rigid geometry of the lower part, I strewed some papers, including a nice touch of pink. I like the contrast between the ordered still life on the top and the comparatively haphazard collection inside, which only has any order from careful stacking.

'I am sometimes asked where I start when I am setting up a still life. Well, as often as not I start with Chardin: he had the best ideas. If you start off with the bones of a good arrangement, you can successfully add your own things afterwards.'

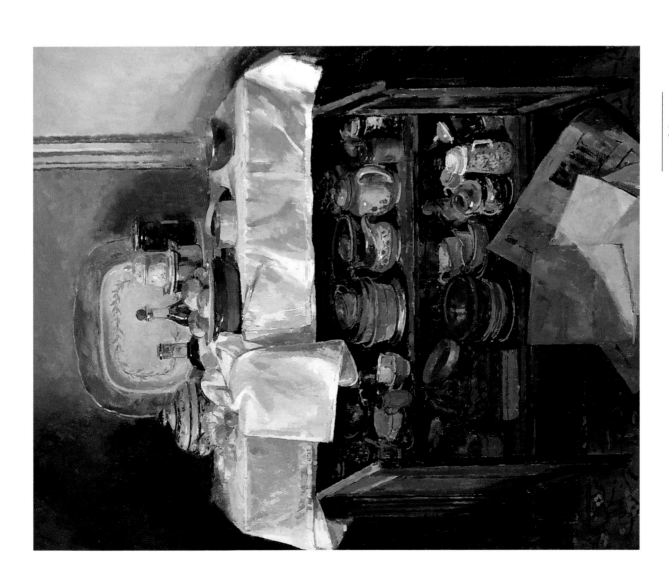

Still Life with Still-Life Cupboard
Oil on canvas, 1987, 30x24in (76x61cm)

The meat dish features again as a full stop at the back of this mountainous composition. A small circular table draped with the sculptural folds of a pure white cloth has come in front of the still-life cupboard, establishing an intriguing architectural configuration of shapes within the deep picture space. Painted with sinuous brush-work, again on a relatively small canvas, the subject is treated with appropriate monumentality. Even the detail, and particularly the accents of the red fruit and tarts, is used to define and embellish the grander shapes and to establish the differing levels within the composition. Pamela Kay:

'For this picture I referred to a painting in the National Gallery in Washington, titled *Still Life with Sweets and Pottery* (1627), by Juan Van der Hamen y León (1596–1631). I first noticed this painting in Alan Gwynne-Jones' book on still life. As well as its staggering colour, it's set on various different levels, and that's what I loved about it. It is also where, incidentally, I first saw the use of a jar of cherries, which Alan Gwynne-Jones said glowed like rubies. Although Van der Hamen was of the Spanish school, as you can tell from his name, his father was Dutch. With genes like that how could you fail to do wonderful still-life paintings?

'My painting is a very clumsy attempt to use this idea of different levels in a still life. And the jar of preserves is there too. The composition is circular – almost a spiral. Your eye is led up the folds in the foreground, where the ellipse of the table is echoed by the objects on it. Then you are taken back and up by the cloth hanging over the front of the cupboard to the spiral of things on the top, finishing off with the plate.

'Composition is the bed-rock of painting, but I think it is an intuitive thing. You have to feel when it's right and you have to feel when it's wrong. If you have rules, invariably that means you get a boring picture, because the painter is following rules rather than intuition.'

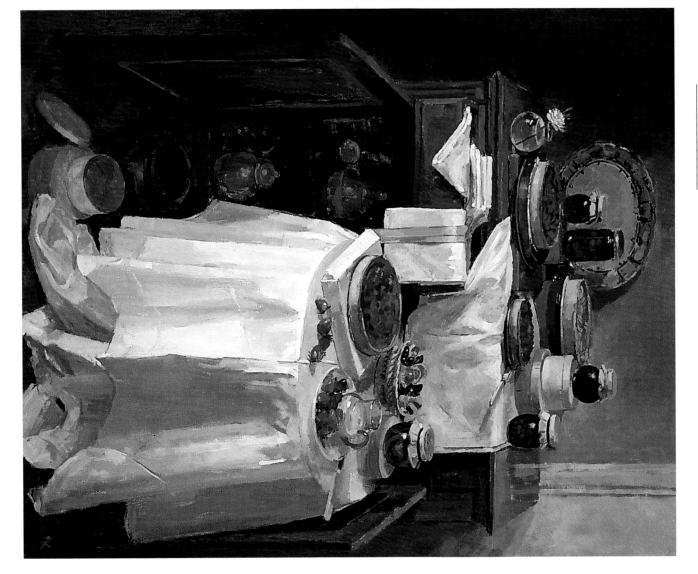

Still-Life Cupboard with Tarts
Oil on canvas, 1987, 30x24in (76x61cm)

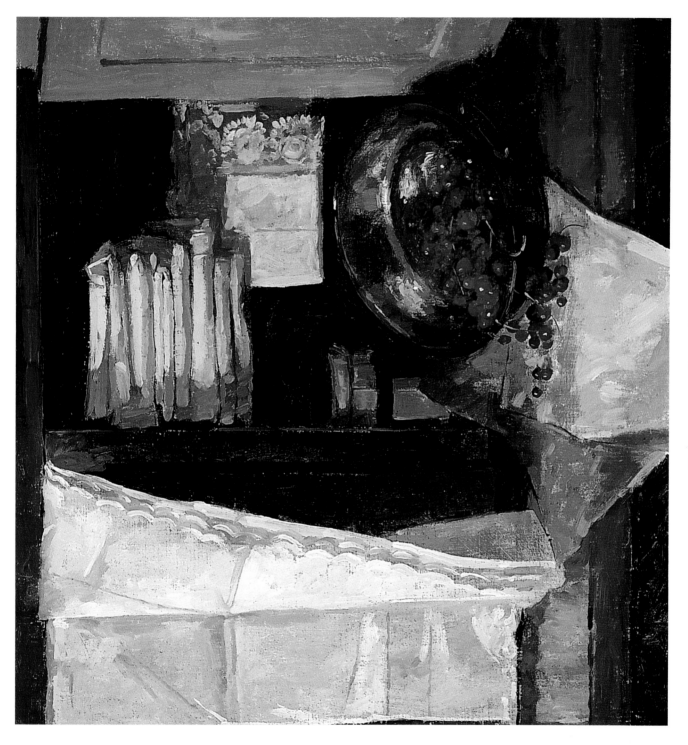

Redcurrants in a Pewter Dish with Linen
Oil on board, 1988, 13x14in (33x35.5cm)

This small cupboard sits on a dresser base. One door is closed, wedging in a cloth, which hangs down in front. The other door is open to reveal a jar and a pile of linen napkins, which has a pleasing, striped effect. The geometric shapes of white cloth, contrasting with the dark wood and set in a shallow picture space, create a pleasing abstract grouping. Against this is the dramatically placed, and excellently painted pewter dish, which spills redcurrants onto the dresser.

From white shapes on a brown background, we move to an array of coloured objects in a white setting. Of course, there is very little pure white, as light, shade and reflected colours cast a subtle, yet rich pattern across the surfaces of cloth. The rippling textures of linen and ribbon, the smooth, glassy surfaces of jars and cups, and the delectable pastries are all described with sensuous brush-work, which enriches an already luxuriant subject. The artist has set up a visually simple, but strong composition, centring on the architectural components of a small set of shelves.

'This little set of Victorian shelves acts as a small stage set. The bottom section has a backing and is an open box, like a theatre stage, where I can arrange things. The top part is open at the back.

'There are some beautiful Normandy apple tarts that Franz Ottiger made for me at the boulangerie-pâtisserie in the High Street.

'Neutral greys are the most rewarding colours to offset against these brilliant reds and pinks. They are made up of white and mixtures of ultramarine and red, which, when it's dried, is glazed with a little very fine raw sienna and re-touching varnish. This warms up the greys. Then I use a bit of sharp, pale cobalt blue and pale light red on their own in among the shadows. This gives a nice zip of pure colour, but the important thing is to get the tones right.'

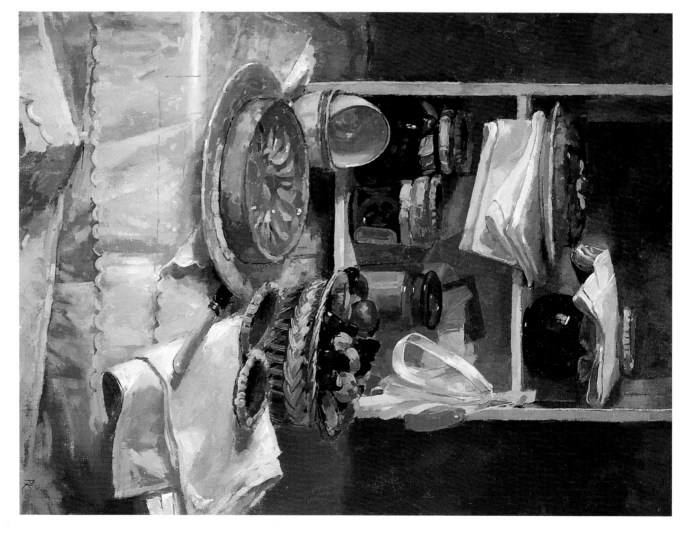

Shelves, Preserves and Many Tarts
Oil on canvas, 1987, 24x18in (61x45.5cm)

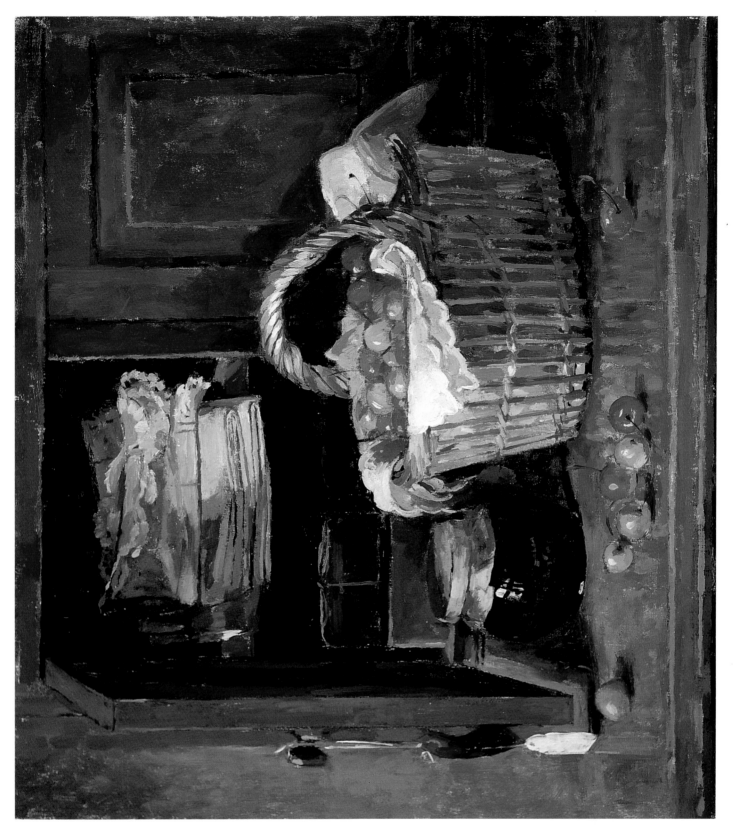

Basket of Kentish Cherries, Small Linen Cupboard and Preserves

Oil on board, 1989, 13x14in (33x35.5cm)

'These are Kentish nap cherries, in front of a cupboard we saw earlier. Again, there is linen on the top shelf and also a little jar of preserves at the bottom. And I have opened the other door. I like it that there is a different micro atmosphere behind the open door. There is a lovely pool of shadow, in front of which I have set the basket, which catches the light and glows that bit more. Cupboards are amazingly versatile and it is extraordinary what you can do with them, once you've opened the doors.'

The canvas is split into two balancing rectangles. The open door cuts a simple line up the side, adding to the asymmetry of the composition, but casts a deep shadow at a diagonal across the dresser top. From the edge of that shadow a well-handled jar of preserves half emerges and the bright basket fully emerges. The complex lighting is crucial to the subject and will have been carefully worked out.

Here we have a more 'country' group of objects, with eggs, bread in a dish, a big copper pan and a basket of apples on the floor. Inside the cupboard are provisions, rather than crockery. The bread is a Welsh bap that the baker, Mr Chapman, makes for me.

'The copper pan came from Stow-on-the-Wold. Painting copper is painting a visual illusion. In art schools you are told you must not do flashy things like that. I thought, "Well, I don't know . . . Chardin had a go, I'll have a go!" I can't paint it like Chardin, but I can *relish* copper like he did.

'Like anything else, you have to look very closely at copper. If you don't do that, you are painting on automatic pilot, which is far less interesting. I can never predict where the high-lights, the vivid orange, the burnt sienna, the pearly grey sheen, the deep maroon inside, are going to be. To anticipate them is to destroy half the pleasure.'

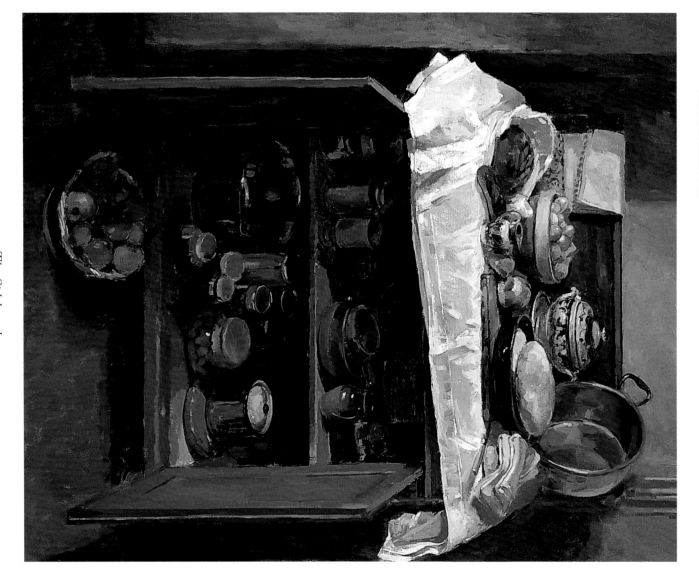

The Sideboard
Oil on canvas, 1987, 30x24in (76x61cm)

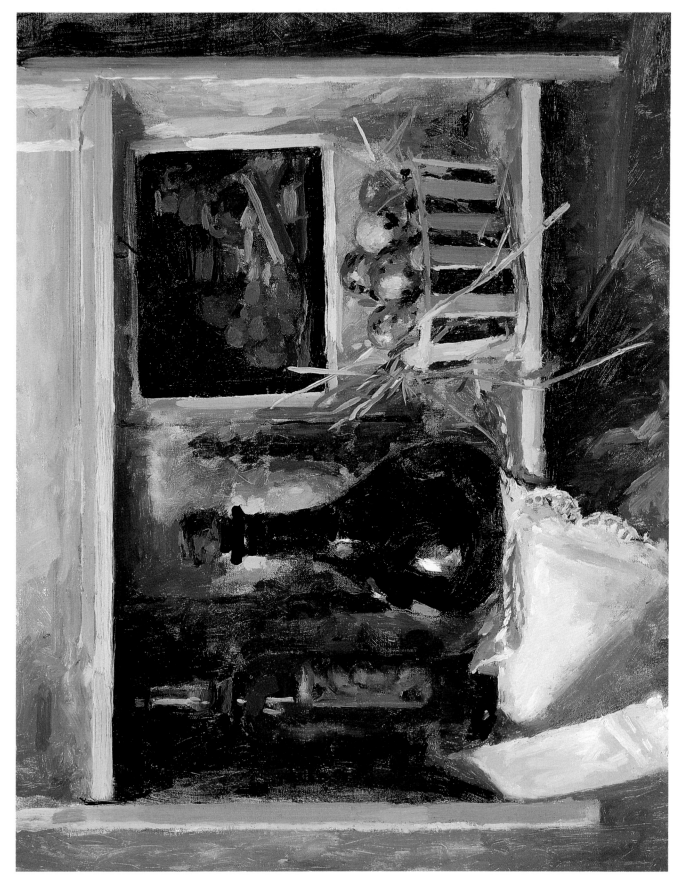

Two Bottles, Quails' Eggs and Melendez
Oil on board, 1989, 10x13in (25.5x33cm)

40

The white Victorian shelves appear again as a miniature stage set. The bottles are as actors in some drama over the basket of eggs, played out in a room hung with a painting by the Spaniard Luis Melendez (1716–80). Pamela Kay:

'The little basket is from Corfu and I filled it with quails' eggs in straw. The superb dark-green bottle was once a champagne liqueur, and has a rather rustic look. There's a little bottle of olive oil behind that and a postcard of a Melendez still life in the National Gallery.

'This was really an exercise in a limited palette. There is just the necessary amount of red on the label of the liqueur bottle to be a good foil to its dark green-black colour.'

'H aving got very interested in cupboard paintings I had a successful exhibition and rashly decided to buy a large Dutch dresser.

'I was at great pains to make this picture not look like something out of a country-style magazine. Someone once told me that when she had her house photographed for a magazine, they imported a lot of beautiful things. They dressed the set. If you are doing a still life at home, I think it's crucial that you paint what you have chosen to collect yourself, not what an interior decorator has thrust upon you. Even though the objects on this dresser were specially arranged, they are all very personal to me.'

These personal objects make up a vertical still-life grouping towards the right of this ambitious composition. Vertical emphases might have taken over the picture, were it not for the horizontal features of the shelves, which help to anchor and stabilise the picture structure. The dresser emerges into the picture space from deep shadow. The powerful chiaroscuro, highlighting the still-life objects against substantial dark areas, helps to create the drama and atmosphere of the grandest still lifes of seventeenth-century Spain.

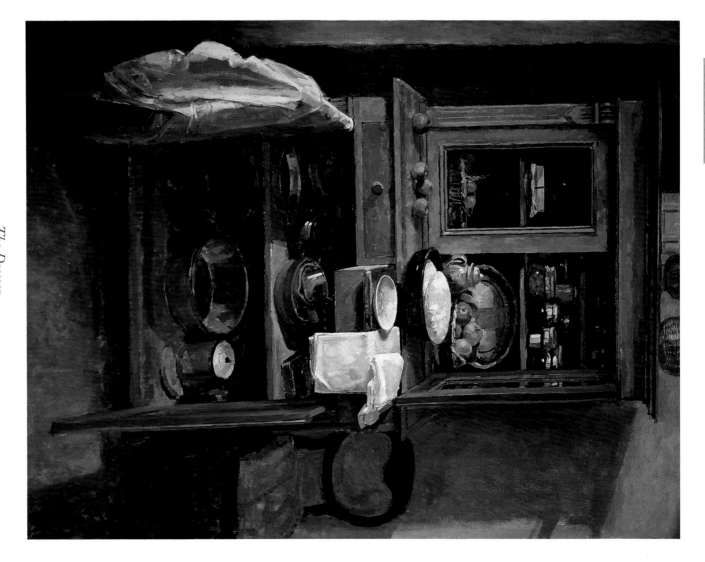

The Dresser
Oil on canvas, 1987, 40x30in (101.5x76cm)

41

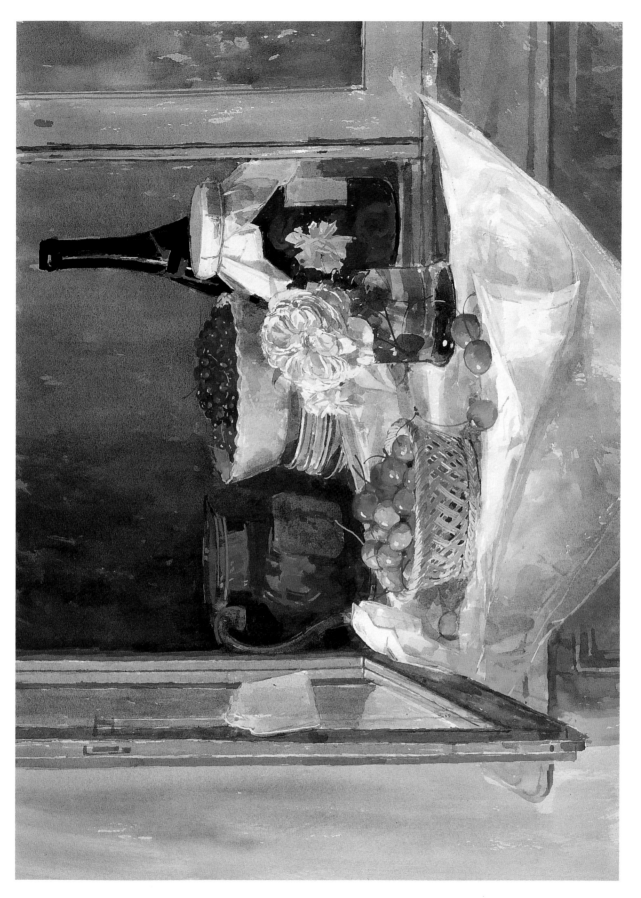

Cupboard with Summer Fruits and Lustre Jug
Watercolour, 1991, 12½x20in (31.5x51cm)

This watercolour focuses on a familiar detail of the pine dresser just described. The open glass-door reveals a rich and various still-life group, which suggests a bounteous summer. As the only cupboard watercolour illustrated here, this work's structure, tone and colour stand up well beside comparable oils. Pamela Kay:

'For a long time my watercolours were too pallid and I've been trying to get them up to the same pitch as the oils. I've never been frightened of the medium, though, because I always used gouache for textile design.'

Although this was painted in the same dark corner as *The Dresser*, the cool light slanting across the picture plane is more reminiscent of the Dutch than the Spanish tradition. Pamela clearly had this in mind:

'The spherical glass Habitat jug with irises has overtones of Dutch still life. You don't actually paint the jug, but suggest it in a change of tone, and the highlight lets you know there is another surface in front of the stalks.

'The little yellow and white coffee-cup and saucer are from the shop at Monet's house at Giverny, and are very reminiscent of the place. Most of the one-off pieces of china in the cupboard come from Lyme Regis, which Leslie Worth recommended as somewhere to really get away for a break. When we went for a walk on the beach and I saw the mud cliffs and the fossils, I had to tell Tony that it was exactly like the Isle of Sheppey, where I was born. He said, "No it's not – Sheppey's horrible; this is lovely!"

'In a back street we came across a junk shop in an old man's front room, stacked high with chipped, cracked and broken pieces of very old china. I managed to fill three boxes with china. Few of those pieces would have been much good to anybody else, but for me they are invaluable and I have had a good many paintings out of them.'

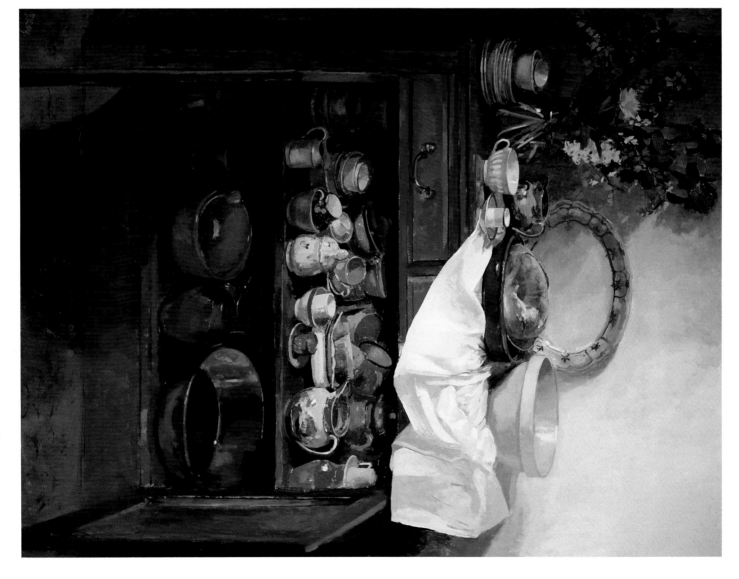

Still-Life Cupboard with Harrod's Loaf and Copper Pan
Oil on canvas, 1991, 40x30in (101.5x76cm)

43

'I had the idea of a harvest festival in the back of my mind when I painted this; it's quite abundant and autumnal, and the cupboard is full of apples and pears in my favourite baskets. The fruit started off as nice tart greens, ripened while I painted, and ended up yellow, the colour of the primrose, which is one out-of-season touch. This proves that there is no logic to painting, nor should it be looked for!

'The light is concentrated on the top of the cupboard, while everything below is fairly dark. The area around the copper pan, where the range of colour moves from the warm of the copper to the cool of the linen, was the most interesting and enjoyable part of the picture to paint. The creamy glaze of the meat dish gives a lovely warm colour, especially where the dish reflects the copper pan.

'The shape of the pan itself is defined by a distorted reflection in warm and cool colours, which you have to study closely. It is painted with raw sienna, cobalt violet, alizarin crimson, cadmium red and orange and burnt umber, all in mixtures with white. There's also some blue-black, to let down the red, but in infinitesimal quantities as it's just to cool it off.

'Hanging at the back is a Victorian Kashmir shawl, which is an important band of warmth, echoing the open door at the bottom right. This sets up a diagonal, which takes the eye up from the French basket on the floor, through the linen tablecloth to the tarts. It's a way of getting the eye into the painting, then making it travel up and zoom about on the top of the cupboard. Otherwise, it's an iron-clad composition, with the verticals having to be broken and cut across.'

This makes a sophisticated composition sound simple. We can make out the grid structure, intersected by diagonals. Yet the disposition of shapes, and the relationship between these shapes within this structure, is complicated and finely tuned. Yet it is important that the still-life arrangement looks as natural as the inherent artifice of the genre will allow.

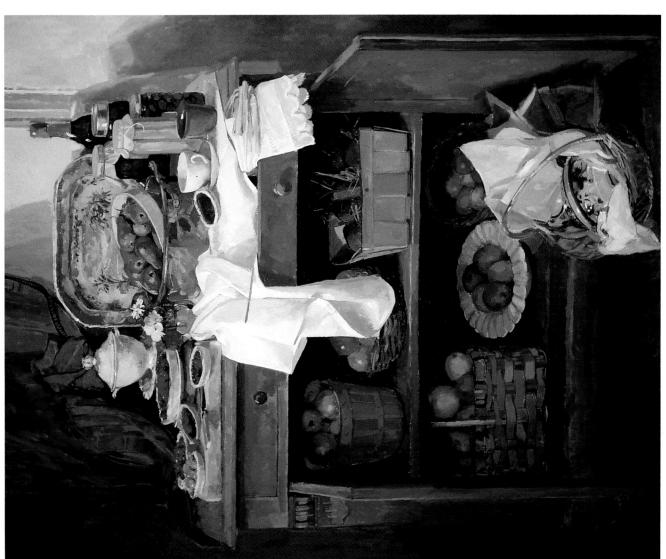

The Apple Cupboard
Oil on canvas, 1991, 40x30in (101.5x76cm) [Detail right]

44

STILL LIFE

One of the earlier table-top still lifes illustrated, the brush-work is slightly tentative and less certainty is shown in the disposition of the objects than we have come to expect. The composition is a forerunner of much that was to follow. The strong abstract framework, made by breaking up geometrically the flat neutral background, is to be seen in much of the artist's later work. The halving of the composition along a horizontal axis, with an asymmetrical vertical division above, is particularly characteristic. Pamela Kay:

'This is the first of my paintings of Mr Ottiger's *petits fours*. They were absolutely lovely little things and he hasn't changed their design since making these. Using them like this is a legacy both of the Spanish and Dutch still-life painters, who painted pastries in the most complex cut-pastry patterns and dishes of sugared fruits. Sometimes they would even gild the pastries, so they were very elaborate things. Blue-and-white china is a great favourite of mine, and I often paint these Spode cups. The little white pot comes from a trip to see my brother in Holland, where blue-and-white china is, of course, very popular.

'I am afraid to say that these delicate, jewel-like primroses and bluebells come from a wood. The common-or-garden cultivated primrose just doesn't look the same and all wild flowers have an incomparable miniature delicacy. But of course they should be left where they grow and I wouldn't do this sort of thing now.'

Still Life – Wild Flowers and Petits Fours
Oil on board, 1986, 14x12in (35.5x30.5cm)

46

Like glowing rubies cut in the round, the redcurrants in this strikingly simple composition are set off by the predominant silvers and greys.

'This is one of the first times I painted redcur-

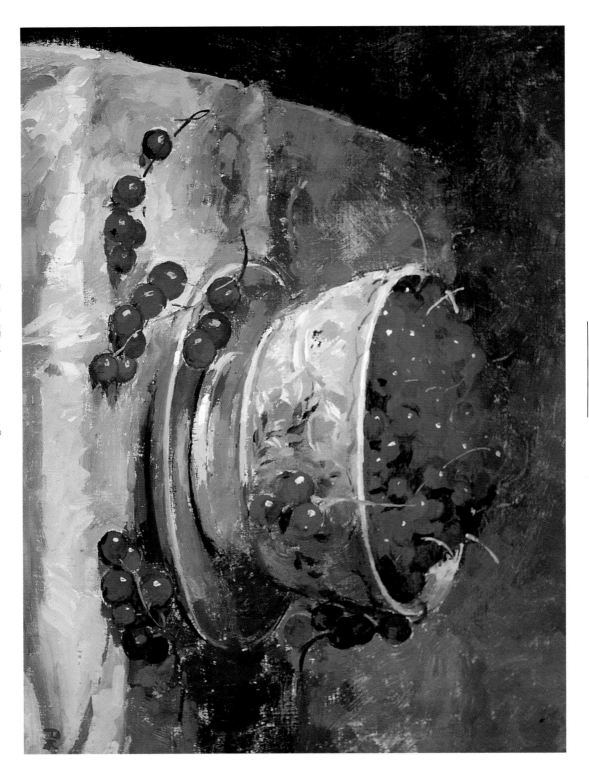

Bowl of Redcurrants in a Saucer
Oil on board, 1986, 8x10in (20x25.5cm)

rants. The bowl was from the junk shop in Lyme Regis and has a raised, pressed pattern around it, with painted flowers. In the Rijksmuseum I had seen the most beautiful painting of cherries in a dish by Jan Breughel (1568–1625). It showed me how beautiful such things could be and I came

back and painted this. When I had finished this, Hannah said, "Under no circumstances, mum, are you to sell that one." So it's now in the family archives.'

the Dutch painters, I have put some pretty unseasonal flowers together in one vase. I would like to think that the Dutch were perfectly capable of producing hot-house flowers in the seventeenth century. The artists would often work from immaculate drawings, using them like pattern books and simply rearranging groups of flowers to form the designs of their paintings. But with their horticultural expertise I think they might also have been able to mix real flowers out of season.'

Earlier, it was observed how Pamela makes sketch-book studies of the few, mainly overseas subjects that cannot be painted on the spot. The Dutch-style intermediary drawing never features in her studio or garden work. But this does not mean that she paints with the direct method of the Impressionists, in which most of the brushmarks go on in a single layer. In the English academic tradition she builds up and then glazes her paintings, and even the broken, feathery brush-work of this sunny painting is no exception.

Slightly larger and more stately than its companion, this painting's voluminous objects are described in an appropriately smoother manner. It is not just the change of subject, for the inherent spring of the canvas dampens and soothes even Pamela Kay's energetic brush, as opposed to the stubborn resistance put up by the linen-covered board, on which the signs of the encounter remain.

Painted around the time of *Still Life – Wild Flowers and Petits Fours*, this work has many characteristics of the later still lifes: the spiralling arrangement, the neutrals of cloth and paper, and the attractive produce and fare. Pamela Kay:

'I made the raised hot-water pastry crust, but there was no game beneath it, just breadcrumbs to stop it collapsing. The other things are all

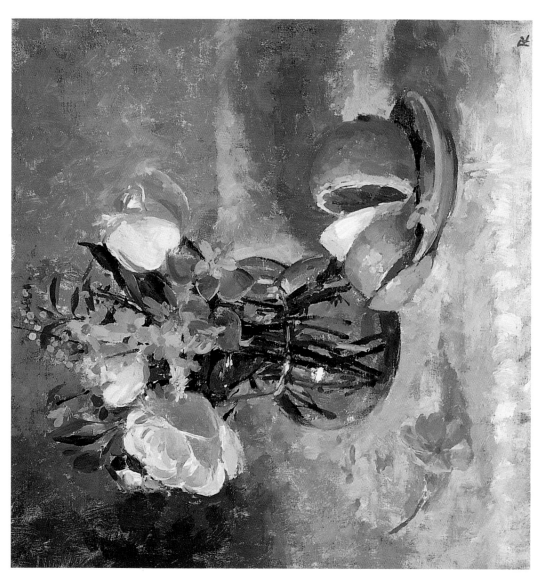

Glass Jug, Cream Roses and Cut Lemon
Oil on board, 1987, 10x10in (25.5x25.5cm)

Here I wanted to keep the colour scheme pale yellow and viridian. It was just a question of putting the right things together, including the glass jug, which has a green cast. With the lemon, I think it all suggests summer. In fact it was painted in January, thanks to Mr French, my wonderful florist, who got me these beautiful pale lemon roses.

'On a Friday the phone invariably rings, and it's Mr French saying "The Dutchman's just

arrived, come quickly!" This man goes to the ferry at Sheerness to collect the flowers that have been sent over by his supplier in Vlissingen. He has a walk-in van and Mr French lets me go in to choose what I want. If I choose, say, grape-hyacinths out of season, Mr French might get a whole wrap of them, which is a lot of flowers. I then might take only a couple of bunches and he's prepared to take the risk of trying to sell the rest!

'The tiny yellow flower is *Soleil d'Or*. So, like

Game Pie and Cranberry Sauce
Oil on canvas, 1986, 14x18in (35.5x45.5cm)

'I see it as quite an English group, despite the bottle of Italian wine at the back. When I bought the bottle in Venice, it was wrapped in this beautiful green paper. I never paint it without the wrapping, and between them they have seen good service.'

Looking for all the world like Rodin's monumental sculpture of Balzac in his great cloak, this motif is one of many that the artist has made her own.

favourites of mine: the basket appearing again with some eggs and the same little pot of preserves, perhaps cranberry sauce, on a pewter plate. Behind them is a pink invoice that I put on the floor in *Still Life with Still-Life Cupboard*.

49

in the jaunty positions of the cherries on the polished wood:

'Part of the joy of painting a piece of wood like this is the quality; not only of the shadow, which sits on the flat plane, but of the reflection, which is muted and a couple of tones lower. Some people regard things like this as illusion only and therefore not quite the done thing. I constantly get a real charge from them.'

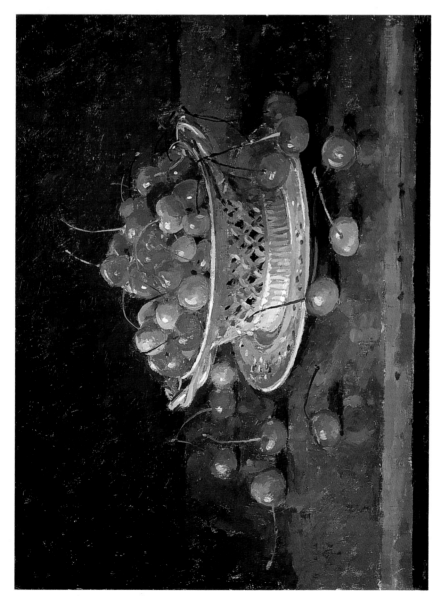

Creamware Basket of Kentish Nap Cherries
Oil on board, 1987, 13×11in (33×28cm)

'This Leeds creamware basket was revived a few years ago and I bought one immediately they hit the shelves. This particular subject has been an extremely popular one, and like the *Bowl of Redcurrants in a Saucer* it was inspired by Jan Breughel's painting in the Rijksmuseum, which is just magical. That was the jumping-off point for all these paintings, especially the way he painted cherries like semiprecious stones. These cherries are special too, with their pronounced highlight and slight translucency.

'Another influence is Chardin's simple image of a wicker basket of wild strawberries, shown in

Like the slightly larger oil painting on canvas of a *Game Pie and Cranberry Sauce*, this is one of the more substantial still-life arrangements of 1986. It is indeed invested with a scale and packed with detail, both of which are considerable for such a relatively small area of board. The painting is only 1in (2.5cm) smaller in each dimension than the picture opposite. Like the latter it relies on a limited colour range:

'It's the colour of the small carnation, or pink, that is important. Much of the rest of the picture is made up of neutrals, while the terracotta and copper are little touches of warmth. I hope the eye is led on a satisfying sweep around the elliptical group of objects. You are brought in with the angle of the handle of the knife and then the ellipse swells up and round in a clockwise direction. You might go the other way, though, starting with the stripy stack of Spode saucers, going up via the pink and round and back down to the knife-handle.'

the 1761 Salon, which is a marvellous example of how little you really need for a still life. In addition to the single image, I have placed a flotilla of cherries on the table-top, which I hope adds to the interest.'

So it does, as does the shimmering, but subtly painted polished table-top. This surface has two notable effects. It gives understated reflections of the colours of the dish and cherries, and it provides a tonally varied background to the counterchanges of cherry stalks from light green to dark silhouettes. The basket itself is painted with obvious relish, and pleasure has also been taken

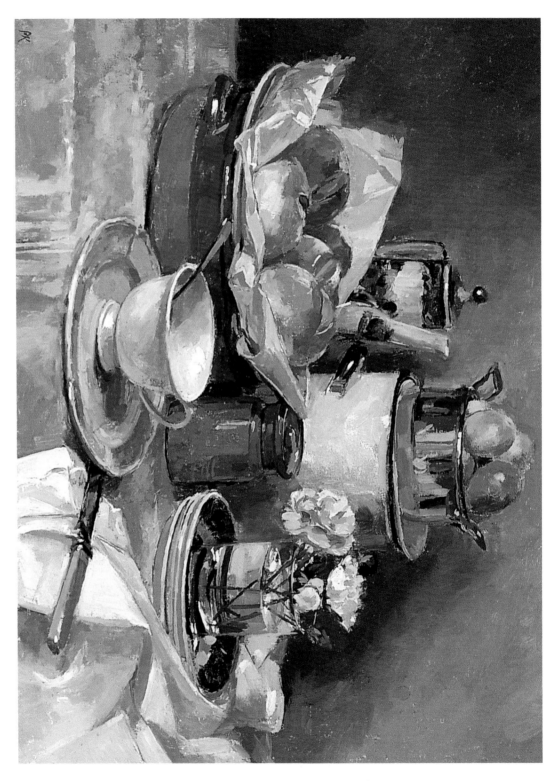

Breakfast Still Life with Pinks
Oil on board, 1986, 12x14in (30.5x35.5cm)

With only Dutch hot-house flowers available to provide much floral colour in an English January, what is better than Seville oranges to enrich this seasonal, marmalade still life? Further winter warmth is provided by the reflections in a well-described copper pan, and a sensitively observed golden cardboard-box containing Mr Ottiger's *petits fours*, which offers a more subtle metallic sheen. Less skilfully handled, the box's muted mirror surfaces might have merged with their surroundings – the differentiations made in colour and tone are minute, but crucial. Pamela Kay:

'The oranges are sitting in a lovely wooden chip tub that I talked a shop-keeper in York into selling me from his window display.

'My grandmother used to salt beans and preserve things in the stoneware jar on the left, which has a beautiful glaze. In the jar in the foreground are preserved mandarins in Cointreau, and there's marmalade in the little jar. They all seem to go quite well together: everything has to be logical in its association. Suddenly, in the middle of all that, you couldn't really have a string of onions, although Cézanne could have done it.'

But Cézanne is relevant here, for the organisation of this still life is reminiscent of some of his monumental structures of fabrics and fruit. By way of example, Pamela Kay quotes the example of *Apples and Oranges* in the Musée d'Orsay, in which the central feature is a fruit-laden *compotier*, set on a mountainous arrangement of carpet and linen:

'It has a profound richness. I remember standing in front of it, looking and drawing, and then realising that I had been there for an hour: there was so much to digest. Cézanne's palette intrigues me, because it is so individual. His blues are sensational, as are his pinks, which have a warm, peachy quality, especially when he paints onions!'

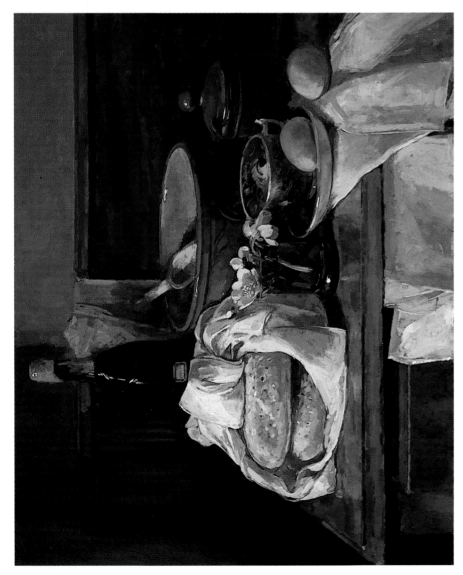

Batch Bread Wrapped in a Napkin with Christmas Roses and Coriander Vinegar
Oil on canvas, 1988, 16x20in (40.5x51cm)

With a glass of hellebores, or Christmas roses, at its centre, this is a winter still life, painted in the dark January days. In a muted palette, the various objects here nestle among a structured arrangement of white linen, like geological features on some Alpine peak. While the composition may be monumental and ordered, it is built up with a deftness of touch and subtlety of colour range that allow the eye to move smoothly up the linen folds and around the circular arrangement of objects. Pamela Kay:

'This and the next painting are set in much the same place on the dresser and the backboard gives a good rectangle of dark tone. At the back is a large bottle of French herb vinegar that I got in Bath. It has very tart yellow sealing-wax on the cap, a lovely home-made label and a superb, rich, dark colour, which makes it a good vertical element. It was shown up by draping the cloth behind it, otherwise it would have been lost in the backboard of the dresser.

'I am certain I have seen bread tied up in a cloth like that in a painting in Madrid or Amsterdam. It reminds me of when I had the mumps as a child, and had a cloth tied round my chin to keep my throat warm. It's also how my father's dinners were sometimes tied up when I took them to him.'

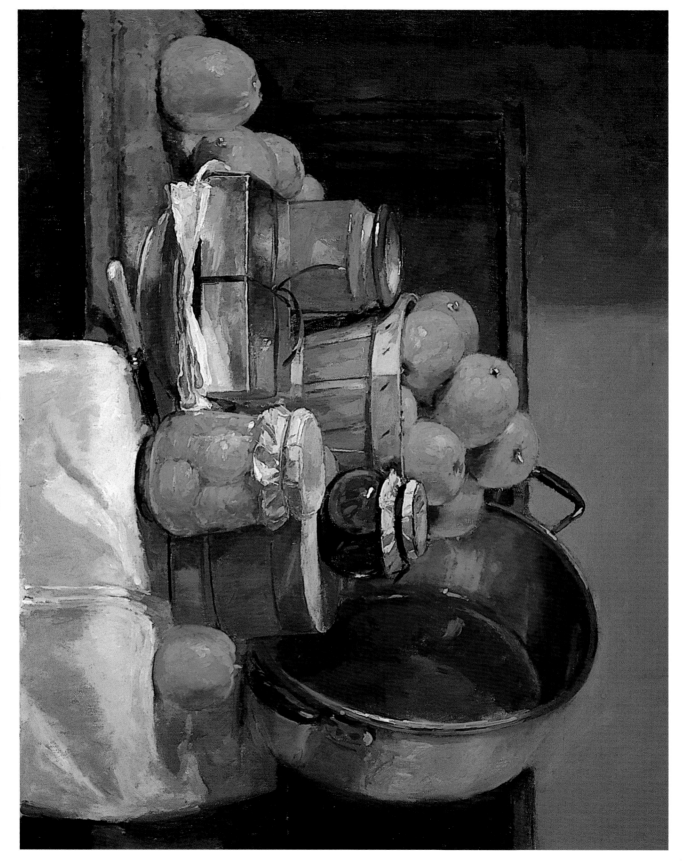

Marmalade Oranges and Gold Box
Oil on canvas, 1988, 16x20in (40.5x51cm)

53

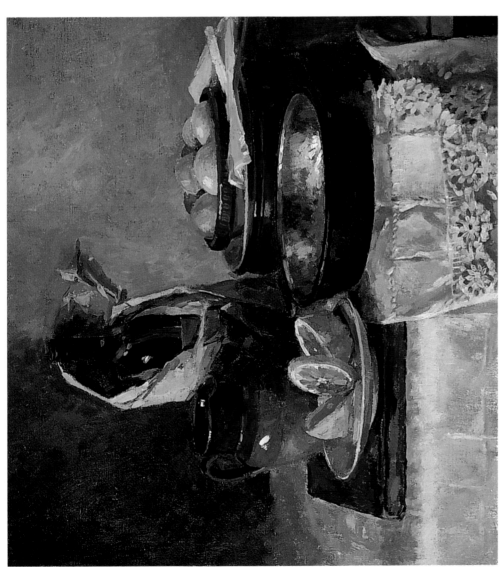

'The highly polished pan is my mother's. When it's old and well used it takes on a particular sheen – the pewter equivalent of my large copper pan.'

I painted this canvas immediately after we came back from Siena. While we were there I saw the most wonderful basket, hanging up, full of chestnuts, in a greengrocer's. He wouldn't sell it to me: I couldn't make him an offer he wouldn't refuse, because it had been in the family for such a long time. Round the corner, however, there was a shop that sold baskets. They didn't have one like his, but this was the nearest to it that I liked. It's very much a country basket, although I'm sure it would be impractical, because the handle is too slim. I loved the colour and decided to fill it with lemons, which seemed appropriate to Siena.

'The setting is a card-table covered with tissue-paper and some old newspaper, which had gone the most gorgeous yellow-orange. The plate with the cut lemon also came from Siena, as did the little flagon of olive oil and the jar of olives. And there is Mr Chapman's Welsh batch bread, looking fairly appropriate and the right colour. The jug at the back, which is a beautiful burnt sienna colour, came from a junk shop in Canterbury, but I think the feeling of an Italian still life remains.'

As in the painting opposite, the quality, texture, tone, colour and light of objects are faithfully described with a fairly free brush. The slabs of Welsh bap bread, for example, have a presence that would not have displeased a follower of Caravaggio. Indeed, this canvas is Italianate not just in subject, but also in the dramatic lighting and use of chiaroscuro. Pamela has arranged a screen so that, rather as in Caravaggio's great painting of *The Calling of St Matthew* in S. Luigi dei Francesi, Rome, the light appears to pour in through a high window, hidden to the side of the picture, and bathes the principal subject.

The Pewter Dish with Lemon and Eggs
Oil on board, 1988, 13x14in (33x35.5cm)

This simply arranged painting is full of good descriptive passages: the brown-glazed jug with its highlights, the gleaming bottle of wine from Venice, the exquisitely metallic pewter pan. The gently spiralling composition is reassuringly simple. The colour scheme is technically subdued, but the artist injects life into the earth colours and cool greys with lively handling and hints of reflected colour. Pamela Kay:

'This painting is of neutral colours, which make the lemons zing. On the other hand, it can't all be cold and needs the warmth of the eggs, the casserole and the jug to alleviate that. Lemons are wonderful to paint, no matter what time of the year. You can do so many things with them: simply chopped in half they look nice, or you can cut slices off and paint the cut sides.

'Around the neck of that familiar wine bottle are a red ribbon, which looks stunning against the dark glass, a twig from the vine and a hand-written label. I think by then I had owned the bottle for about four years. It is very definitely a still-life prop and not for drinking.

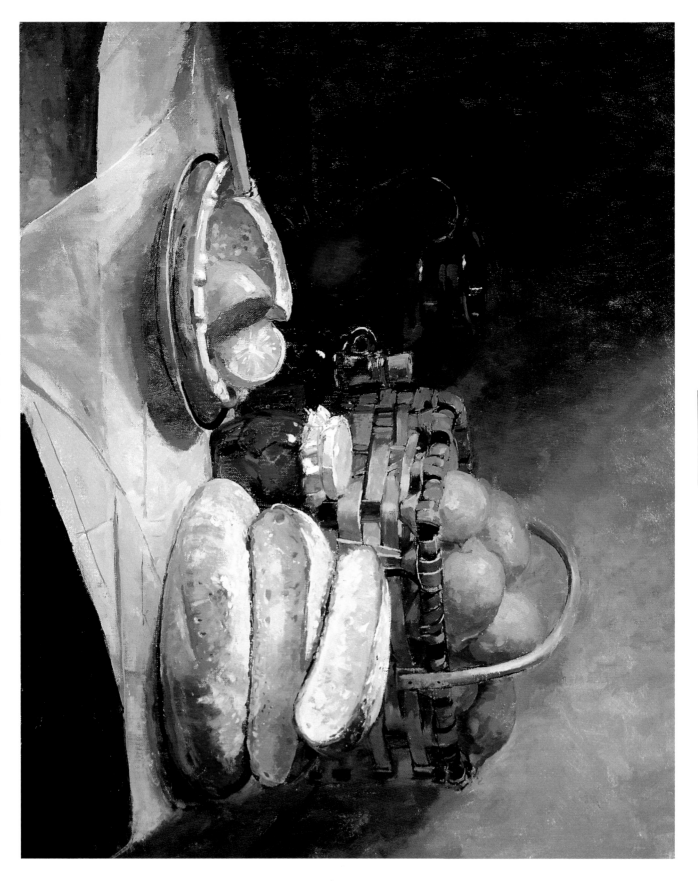

Italian Basket of Lemons and Bread
Oil on canvas, 1990, 18x22in (45.5x56cm)

'On the left is a little cream churn from Holland, and in front of that a beautifully plain white *Rosenthal* cup and saucer. Behind that is a jug with a picotee-edged poppy and some little white Kiftsgate roses. The Kiftsgate rose is one that grows faster than man can run. At Kiftsgate Manor the original is a huge, rampant hedge, as big as a house. This rose is also extraordinary because it's a single flower in an umbral formation, like cow parsley.'

Light in tone, this watercolour bears the airy freshness of a summer's day. The basket of peaches introduces the only strong, warm colours to disturb the cool, pastel harmonies, and is a necessary anchor to the composition. Without strong light or shade, this colour and tone change also helps to define the position of objects and the sense of three-dimensional space within the picture, which is enhanced too by the open drawer and cloth projecting into the foreground.

This darker-toned watercolour is a good example of the richness of colour, tone and line that the artist is able to achieve in the often described as 'slight' medium of watercolour. For example, we see the characteristic broken-brush background, with a wet, dark grey vigorously washed over a lighter tone, the resonant red of the pansy and the almost gestural drawing of the bellis daisy stalks. Pamela Kay:

'If you are not careful, a still life can get very "puddingy". If you just have lumpy objects like bowls and dishes, they can look too solid. The particular and individual aspects of plants do much to lighten the picture. The bellis is an early spring daisy that is very tight, like a little button. What I liked about these ones was the way they have gone mad, slightly wild. There is a lot of drawing in the stalks and they are the sort of thing any draughtsman would go for immediately.'

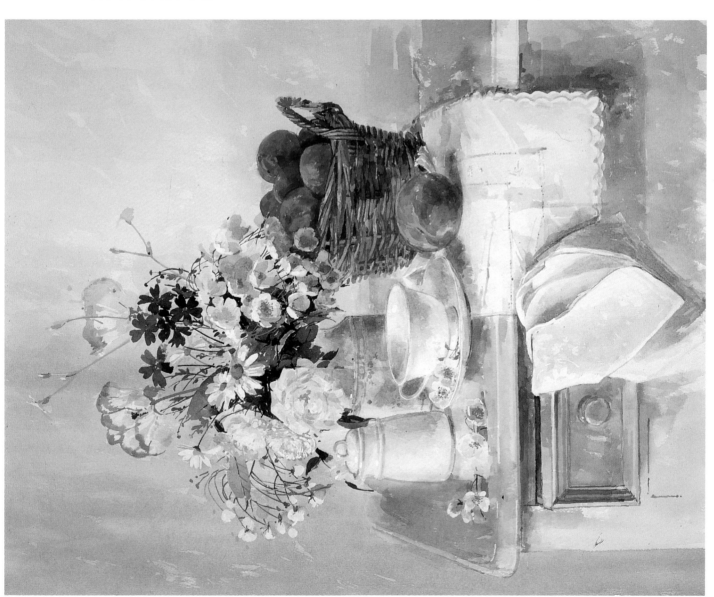

Jug of Summer Flowers and Basket of Peaches
Watercolour, 1989, 22x18in (56x45.5cm)

Bellis Daisies and Pansies in a Basket
Watercolour, 1988, 12x18in (30.5x45.5cm)

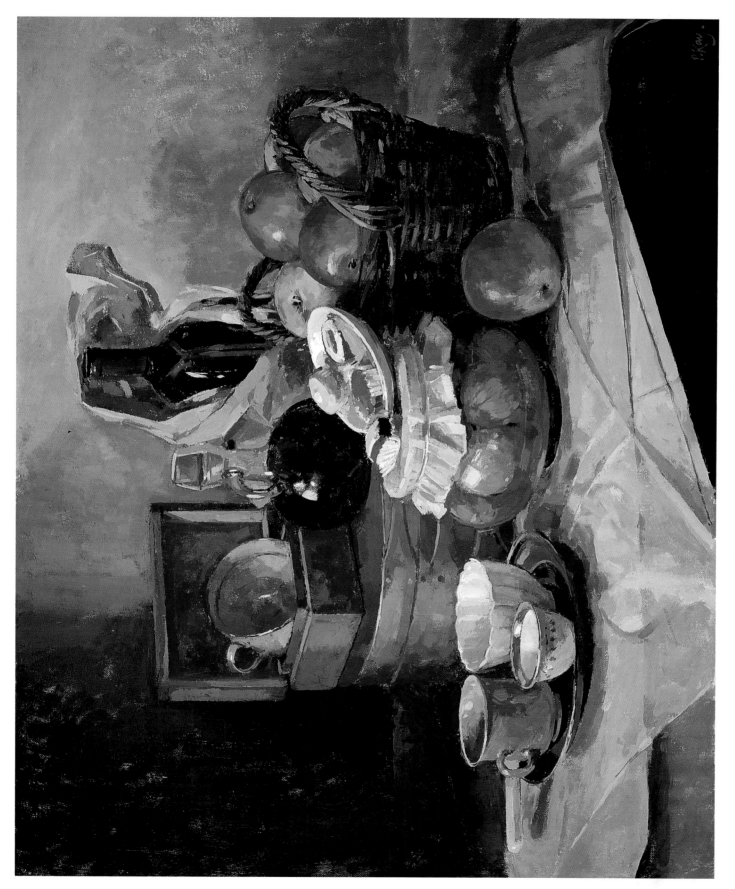

Preserved Oranges and Basket of Apples
Oil on canvas, 1990, 18x22in (45.5x56cm)

The newspaper and tissue are in a similar position on the card table as in the *Italian Basket of Lemons and Bread*, which was painted immediately after this canvas. The flagon of olive oil appears in both paintings, and here we see once more the Italian wine bottle in its wrap. Somehow, though, the autumnal colouring and motifs of the apples suggest an English rather than an Italian still life. The generous fare includes some of Mr Ottiger's *petits fours* and among the porcelain from Lyme Regis it is worth spotting the definitive handling of the gilt rim of the tea bowl in the foreground. The overall richness of effect and the piling up of mainly rounded objects is well counterbalanced by the linear pattern and plainness of the newspaper and tissue. Pamela Kay:

'I hung onto the arrangement of papers for quite a time because it was a unique natural occurrence, quite accidental, and would have been difficult to repeat. Although it may look it because the apples have got a high colour, the colour range is really no wider than my normal restricted palette. Essentially, it is made up of reds, greens and neutrals.

'It is really a wedge-shaped arrangement, with the plate inclined to help the eye skid down to the three little cups at the bottom. The triangular arrangement is a classic, Dutch form, sometimes more obtusely used than others. All my arrangements are essentially geometric. I suppose if you wanted to analyse it, there are quite a few triangles in this picture, but they weren't consciously chosen. I arrange the still life until I consider it right, so it's an instinctive process.'

The violas in this painting come from Northbourne Court, near Deal, which, of course, has a beautiful garden. When I buy a plant like this I usually paint it immediately, to get full value from it, and then I put it in the gar-

den, where it instantly dies! Behind the viola is a teapot for infusing herbal teas that came from Madame Cadec's fantastic kitchen shop, when she was in Soho in the late 1950s. I was a student, and like many others went there to discover all the real French kitchenware.

'Behind the pot is the basket of sloes, which have a beautiful bloom. Behind them is what I call a muffin dish, although it probably isn't: a little domed metal dish, which gives beautiful reflections. And in the front are some plums and Kentish cob nuts, adding to an autumnal feeling. The whole thing is set on a very old chopping-board. Tony brought it back from Hong Kong

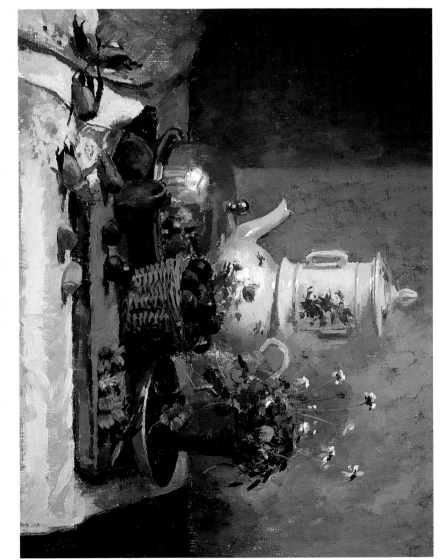

Cob Nuts, Basket of Sloes, Muffin Dish and Violas
Oil on board, 1989, 12x15in (30.5x38cm)

and it has weathered a bit and got some nice characteristics to it. New ones are very dull to paint.'

This airy study of flowers, fruit and nuts is handled with a light and lucid brush. Offsetting any suggestions of spontaneity, however, is a strict geometric arrangement, with the triangles of vessels and flora intersecting the dark rectangle of the background screen and the dark wedge of the table-top.

'This is a pansy that just went wild. No plantsman would have given it houseroom, because it was all leggy. But it was for this reason that there was a whole cascade of blooms down one side, forming this absolutely wonderful sweep.

'I think it was unconscious at the time, but the design probably originates in a miraculous picture called *Quince, Cabbage, Melon and Cucumber* in the San Diego Museum, by a Spanish painter, who became a monk, called Juan Sánchez Cotán. His composition is based on a wonderful parabolic curve, and that is something which happens in a much more modest way with these pansies. The sweep comes down one side of the pot and is continued on with a little green glass, filled with daisies and one marigold. Overall the painting has quite a neutral, ultramarine and mauve cast, and then suddenly there is the foil of that one small spot of orange at the bottom of the parabolic curve.'

Once alerted, the viewer becomes conscious of the compositional curve, which in itself gives pleasure in its simple honesty and clarity. The angled tissue-paper and newspaper, which we saw rather more yellowed in the oil of *Italian Basket of Lemons and Bread*, just provide the necessary base to the plunging flowers. Behind the arrangement is a typically rich, broken-brush backcloth. Pamela Kay:

'I find it hard to get myself worked up about a flat wash; unless it is handled by someone like Russell Flint or Leslie Worth, I think it can produce a very dull piece of paper. Here I would have started with a pale grey to brush in the background and to help assess the tones. Then, as it dried, I would have probably thought it wasn't dark enough and, when it was very dry, put in a darker tone, leaving a flickering from the tone underneath. Changing the tone or colour halfway across gives even greater interest and variety.'

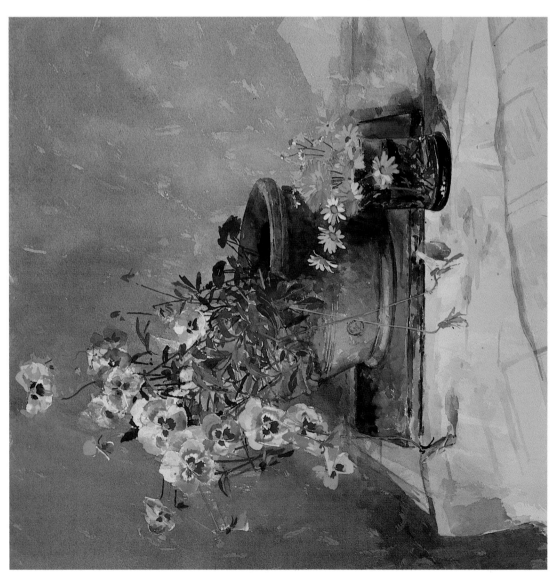

Pot of Pansies and Glass of Flowers
Watercolour, 1990, 18x22in (45.5x56cm)

'This watercolour was, in fact, made in January, using hot-house flowers imported from Holland. Towering over the arrangement is a pot of narcissus, *tête à tête*. Because it is growing, I of course have a little more time than I do with cut flowers. Behind those are paper whites in a brown jug, with a white pansy on the left. I painted in all these flowers first, because I wanted to get the whites and yellows onto the paper at an early stage so that there was no risk of covering the paper with a dark wash. At the front is a basket from Corfu containing eggs, some kumquats for a touch of orange, a primula or winter primrose on the right and pansies behind.

'This painting is really about opposites: orange and yellow and purple, in among the neutral browns and greys. Spring flowers are so stiff and unbending that you have to be quite architectural in the arrangement. A poppy is going to flop about and look absolutely gorgeous and wayward and eccentric, but spring flowers are very rigid, and you have to work accordingly.'

Within the circular arrangement of this Manhattan of a still life are something like seven different levels. Isolated on the tablecloth, in a composition that almost vignettes towards its edges, this spiralling structure leads the eye around the array of coloured blooms. Once again the artist proves that there need be nothing static in still-life painting, despite the relative rigidity of her subject.

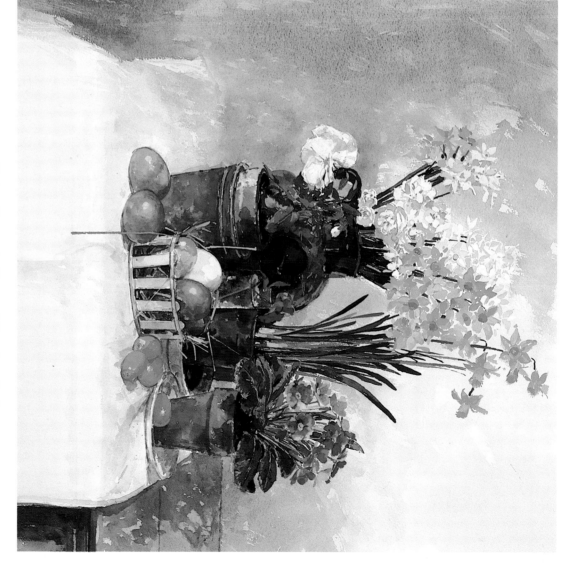

Spring Flowers in Pots and Eggs in a Basket
Watercolour, 1989, 19x22in (48x56cm)

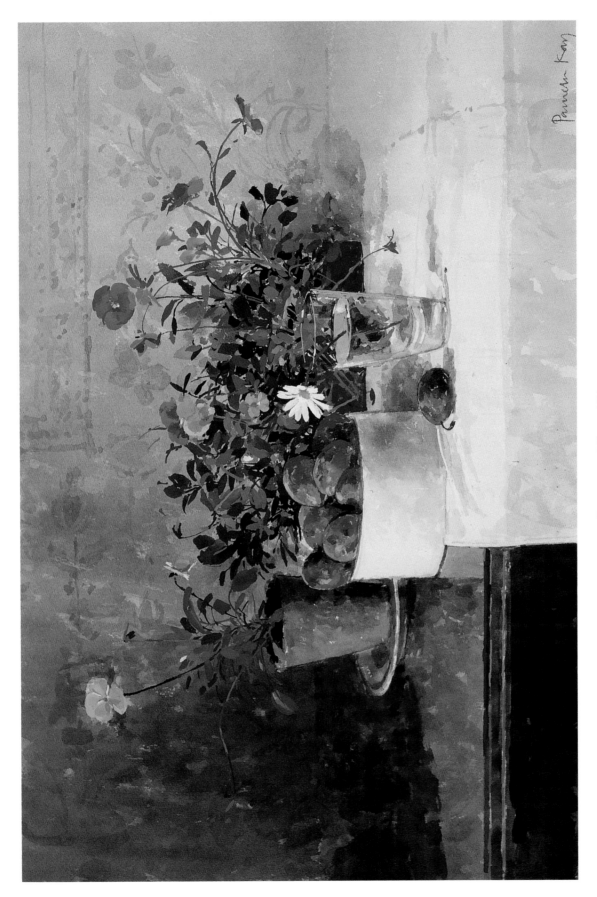

Pansies and Box of Plums
Watercolour, 1988, 13x19in (33x48cm)

In this watercolour the artist does not allow the greenery to blur the as-ever determinedly chosen positions of objects, but the flowing stalks and leaves do provide an amiably verdant background to the group.

'This is just some damsons and, at the back, a range of rather spindly violas and very small pansies that you get at the end of the summer. At the front is one daisy in a glass. Chardin once painted a single glass of water and it was like a diamond – sensational where the refraction took place. There is a lot of beauty in a simple glass of water, and to me a glass of water and one daisy is even prettier. But the main thing about this was the forest of tiny leaves in the background, which flicker about. And in the flowerpot is a yellow pansy which provides a colour counterchange.

'With the table only two-thirds covered with the cloth, you get the best of both worlds: there is a slight reflection on the table-top, as well as a dark side and a light side. At the very back is hanging a large Indian block-printed bed-hanging, or *palimpore*, which I got in a junk shop. It has the most beautiful siennas and madder pinks, and makes a lovely overall colour for a background. Down the extreme right-hand side I barely have a line where the table-top stops and the hanging starts: I just let the two gently float into each other to minimise the distraction from the near-focus objects.'

———

Three years on is another late-summer working on a not dissimilar theme and for-mat. In both cases the colouring is slightly sombre, something the lighter background re-inforces rather than dispels. With the exception of a finely described silver dish, we see a group of unpretentious, even unprepossessing objects, unified by the subtly painted plants and a soft lighting. The tonal changes from object to object are slight and undramatic. Pamela Kay:

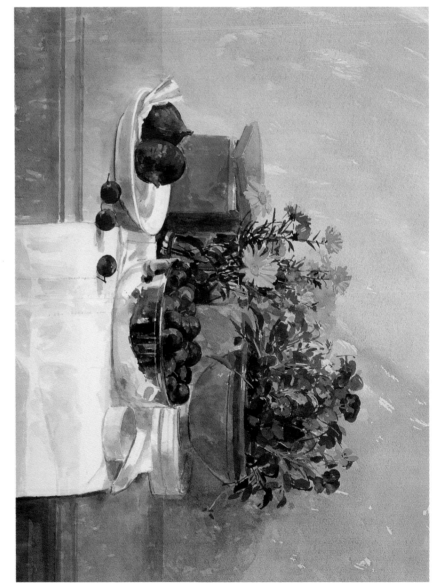

Silver Dish of Damsons, Figs and Flowers
Watercolour, 1991, 13x18in (33x45.5cm)

'The dish with figs came from Madrid and is very plain and simple. The little box on the left-hand side is one that I got in Odessa. It has a rather severe design, with a cushioned top, and is made from a beautiful bird's-eye maple. The silver dish containing damsons is something I love to paint. It will hold anything and look stunning, because of the reflections. You don't actually paint the dish, but the effect on it of surrounding objects, which is really much more interesting.

'Each year I like to paint damsons if I possibly can, because of their lovely bloom. Not being as big as plums, there is something rather delicate about damsons, and they feel autumnal. There is something comforting about painting the seasons of the year. Throughout your education, your whole year is governed by school terms. When I got married my year was still governed by the school timetable, because Tony was a head-master. Now he has retired, my year is governed by the seasons. This is more satisfying, although the school terms are not so far removed from the seasons. If I cannot get round to painting some-thing one year – cob nuts, for instance – I regret it and feel as though I really have missed some-thing. Instead of thinking, "Oh, good grief, it's cherries again", I can't wait. I think it's absolutely wonderful.'

'Invariably I use a folding screen, just to cut off the light from the studio window and to give it direction. You can control the light flow if you've got a baffle, which makes it more interesting and less flat.'

Each carefully lit and defined object sits isolated in space, yet plays a role in a triangular arrangement against a starkly quartered background. Classic Dutch and Spanish influences lie behind the composition of this, one of Pamela Kay's most formal still-life paintings. Even the objects on view have a pedigree:

'This is my Sébastien Stoskopff basket. It is very similar to one Stoskopff (1597–1657) used in a painting called *Pâté and Basket of Glasses*, in the Musée des Beaux Arts, Strasbourg. His basket had glasses in it and looked lovely, and I had been trying to get one like it for ages. In a flea market in Brussels I spotted this, clearly old one, and surprisingly enough it contained glasses for sale. I haggled for it, but the woman who owned it wouldn't sell the basket by itself, and I had to pay for the glasses and then leave them with her!

'This painting also harks back to Juan Van der Hamen y León. The brown paper-covered box was an attempt to vary the height, as he did in his picture *Still Life with Sweets and Pottery*, with an extra level and a ledge at the front. In the foreground is a most beautiful terracotta beaker that my daughter Victoria made for me. I had seen one like it in a painting called *Le Dessert*, by Georg Flegel (1563–1638), so she copied it and this is the first time it appeared. It gets a wonderful quality of light on it, with a matt outside and a reflection on the glaze inside. Next to the strawberries and the flask of Sienese olive oil is a Shaker cup and saucer, and there is Shaker linen under the round Shaker box. The whole thing is a very geometric arrangement, almost like a Battenburg cake!'

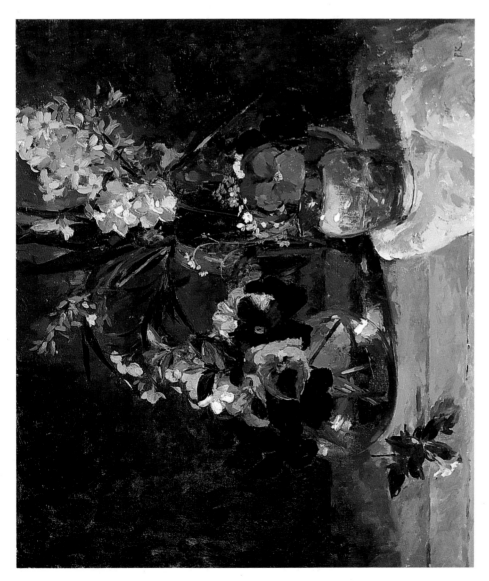

Spring Flowers and Pansies and a Spode Jug
Oil on board, 1991, 12x14in (30.5x35.5cm)

This was a spring painting: a collection of spring flowers in jugs and glasses. They include a new variety of pansy: a gorgeous pink colour with a dark blotch in the middle. There are also some rich, velvety mauve pansies behind and a few tiny bits of *Soleil d'Or*. At the right-hand side is a hyacinth, and in front of that an old Spode jug with a similarly blue pansy in the neck.

'To give a change of plane they are all sitting on a chopping-board. On the front edge of that I have placed a forget-me-not to fill the space on the left. Behind it is a round glass of the sort the Dutch were so good at painting, with single stems and a lot of reflections.'

There is the sense of the sketch about this small, vigorously painted picture. Perhaps the delicacy of the spring flowers led the artist to rush to capture their living being before they wilted. The fluid brush-strokes that describe them are held firm by a dark background, which brings out their jewel-like qualities.

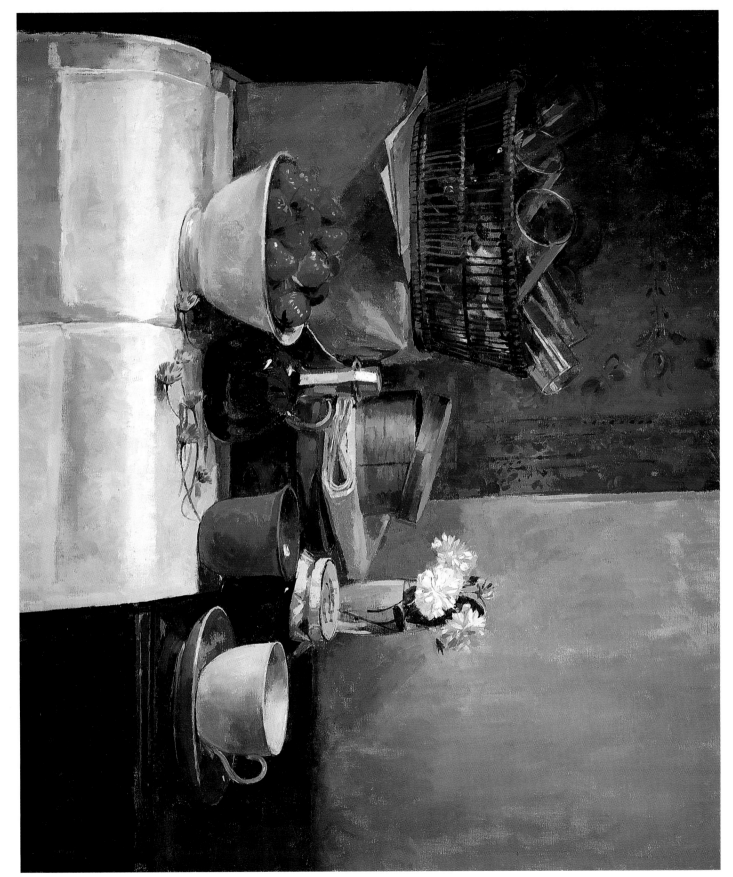

Basket of Glasses and Dish of Strawberries
Oil on canvas, 1991, 20x24in (51x61cm)

65

'The scalloped dish containing the nap cherries is from the shop at the Louvre. It is a replica of the dish that was used in a painting by Lubin Baugin (1610–63), which the Louvre owns, and in the mid-1980s they found bits of a similar dish while digging in the *Cour Napoléon*. The original was probably Italian *faience*, that I think was much treasured in the seventeenth century and was painted by a number of still-life artists of the time.

'I did a whole run of pictures of these poppies, which grow in the garden. I almost like painting the stems as much as I like painting the heads: there is such variety when you get a whole mass of them jammed into a jar.'

If there were a standard reference manual from which Pamela Kay composed her still lifes, it is unlikely that any passage would read 'Fill half of your picture area with a flat plane of white cloth, positioned centrally and to the fore. Behind this paint a broad grey background. The still life goes in the bit that is left.' Yet here it is, and it seems to work.

It may help that paper and cloth are made of a similar material, as the artist habitually uses rag-made Waterford paper. To enliven the surface she picks out the grid of well-pressed concave and convex folds, sculpting them, as it were, with the raking light. They give the cloth and napkin a geometric pattern of tonal changes across the surface, which itself echoes the overall structure of the composition.

Some tissue-paper counterbalances the point of the tablecloth at the bottom right of the picture, thus setting up a diagonal axis. Down the left of the composition runs a vertical line, which is reflected on the right, where the dark grey tone changes into another flap of the screen. So in essence the watercolour consists of three vertical panels, with a horizontal intersection dividing off the top third. It is in this context that the pattern of the tablecloth plays its part.

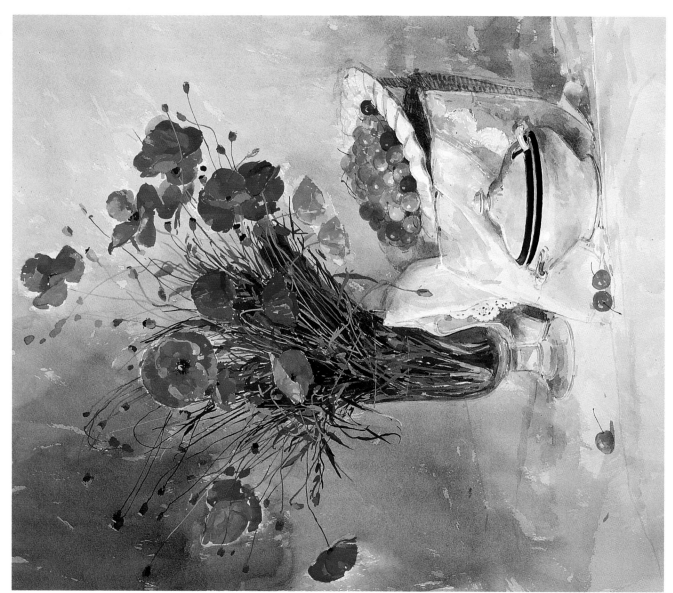

Poppies, Dish of Cherries and Tureen
Watercolour, 1990, 22x18in (56x45.5cm)

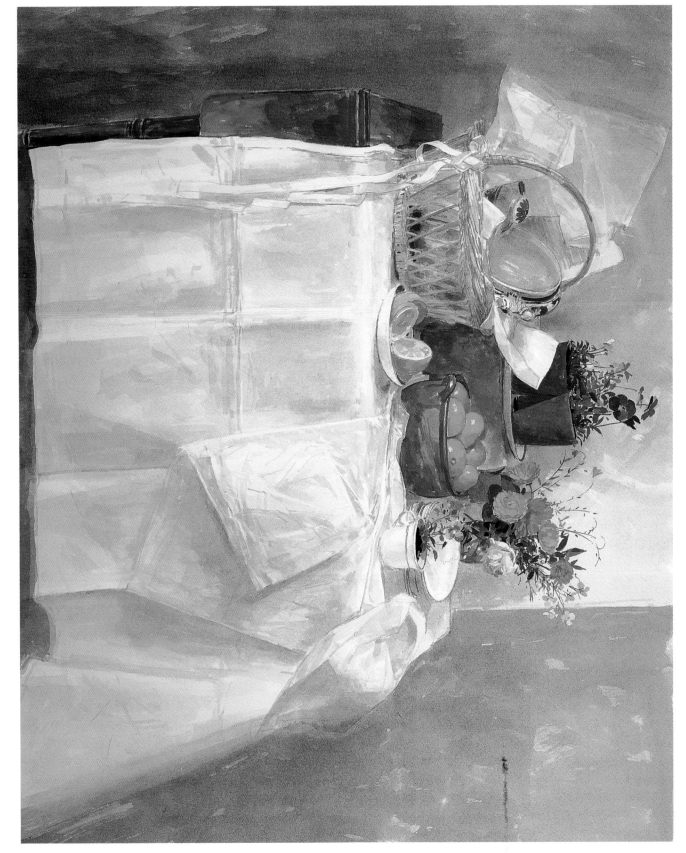

Large Table Still Life, Clementines and Marigolds
Watercolour, 1991, 25x33in (63.5x84cm)

Another oil painting on board, more broken brush-work, a dark background: there the similarity ends, as the brighter light on the white cloth and a combination of pinks and reds combine to heighten the key and lift the mood. The cherries and beautifully painted centifolia roses suggest the pleasures of summer. Pamela Kay:

'They are Fantin-Latour roses, named after the painter. They flower for a very short period, but have a beautiful, deep-coloured centre and these tightly packed petals, pale and very pretty. With them are some preserves and cherries in the Leeds creamware dish.

'The background is once again split, so that the darkest tone is behind the flowers. And then you come forward to the light foreground. The colours are in a kind of spiral arrangement, and also close to each other. The colours of the paper tops of the preserves, for example, are both close to creamware. Similarly, although there is the counterfoil of the greens of the leaves, the reds aren't fighting anything. There aren't many colours in the picture, but there is a lot of richness, and a lot of extremes of tone. And that is really all you need for a little painting.'

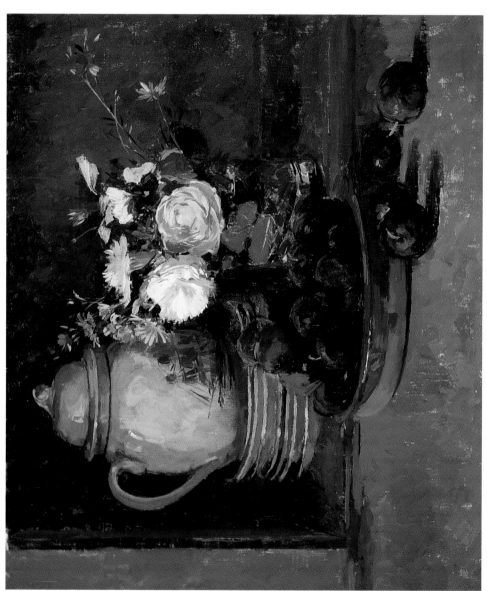

Plums in Terracotta Dish and Teapot in a Cupboard
Oil on board, 1991, 12x14in (30.5x35.5cm)

'The plums are in a shallow terracotta dish with an uneven glaze on the outside. Behind them in a glass are some pinks, a little Madame Pierre Oger rose and some flax, which I grow in the garden because it's such a beautiful blue. Flax looks so much better in the fields than the yellow of oil-seed rape. Next to them is a nicely shaped teapot, decorated with a sailing ship, on a pile of saucers, sitting in a cupboard I had recently bought.'

Serving a similar function to Pamela's screens, but on a smaller scale, the cupboard provides a shadowy backcloth for the still life. From this shadow the teapot and flowers emerge into the light, which as ever comes from the studio window to the left. The wood and terracotta form an earth-coloured setting for the flowers and porcelain, but there is no really selective concentration in this study. We are left to enjoy the warm, rich colours and the scumbled brush-work.

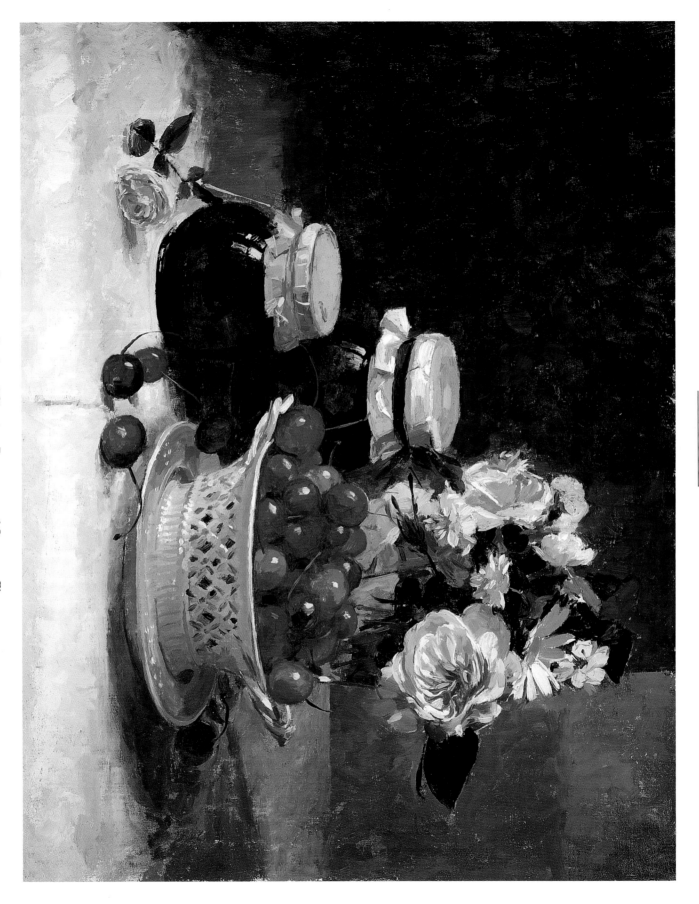

Creamware Basket of Cherries, Preserves and Summer Flowers
Oil on board, 1991, 12x15in (30.5x38cm)

without creating a distraction. The bands of grey also cast a nice reflection on the table-top: small, slight subtleties, but they do make a difference. There is also the light on the cherry stalk against the dark table-top, compared with the darker stalk against the basket.

'I think all these things give a picture sparkle. Counterchange is something a painter is always interested in and looking for. If you've got variety and constant changes of light, level and position, then the eye is kept interested. It picks things up rather than skating across the surface. Whether you realise it or not, the eye notices these apparently hidden things and finds them satisfying.'

The seeds from which we grew these marigolds came from the gardens of the Maharajah's palace in Jaipur. There was the most sensational garden, like an old English herbaceous border, with sunflowers at the back, cosmos in the middle, and beds and beds of these magnificent marigolds. The seed wasn't ripe, but I thought I couldn't miss the opportunity, and came back with almost a suitcase full. The moment I walked in the gate I threw the seeds on the front garden. They all came up and the garden was awash with a sea of marigolds. I was so pleased that I painted this picture in celebration.

'The marigolds are in a dish inside a Shaker basket. Next to them I placed some crockery, including a yellow coffee cup from Giverny and a little Spode one in front, giving a touch of cool blue, complementary to the orange.'

The large and variously coloured flower-heads strike a resonant note against the deep, brown background. Tightly packed and almost jostling for position in their basket, their shapes are echoed by the jaunty arrangement of crockery.

Shaker Basket and Bowl of Nap Cherries
Oil on board, 1991, 9x11in (23x28cm)

'These are Kentish nap cherries in a Shaker basket and a pottery bowl from Divertimenti. I remember thinking how lovely the pale cream colour of raised bread dough would look in that dark brown bowl. In the meantime the light basket does that job quite well. They are sitting on a drop-leaf table, which I use constantly for still lifes. I never think the year has been complete unless I have painted some nap cherries. The irony is they probably come from Italy! But I always think of them as Kentish orchard cherries.'

From quite a high viewpoint, the artist sees the surface of the table at something like 30% from the horizontal, enabling her to depict the disposi-

tion of objects over its surface in three, rather than two dimensions. She is also able to look into the vessels, giving a fuller view of the golden-red cherries.

The angled view also gives a flattened, rectilinear pattern to the table and background screen. Within these cool, painterly shapes are set the warm colours and softer contours of the central group. And this group is very well described, from the counterchanges of cherry stalks across the foreground, to the single glint of light on the bowl rim, which tells us so much about the nature of the whole outside surface of that vessel.

'Using the screen like this is a way of stopping paintings being too quiet or becoming boring,

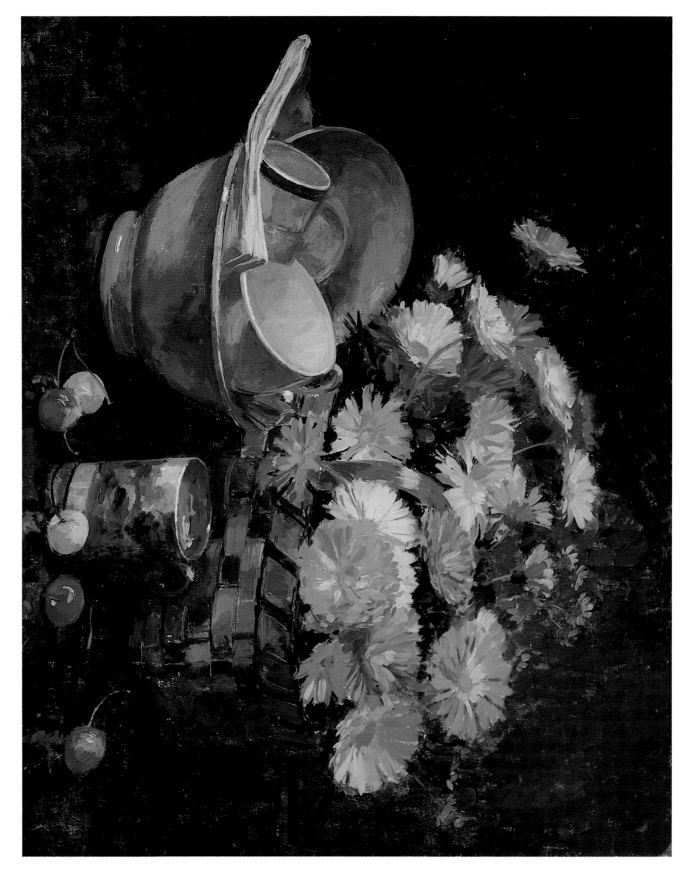

Maharajah's Marigolds and China
Oil on board, 1991, 12x15in (30.5x38cm)

'There is a marvellous antique shop that I always visit when I go to Chipping Campden, which in the basement has rack upon rack of old china. There's a rickety staircase and the ceiling creaks away just above your head, but I have found quite a few things there that suit my needs. The cup in the middle of this group is one example, which I got for its unusual, wonderful powdery blue. On the right is a lovely French *daube* casserole, which came from Stow-on-the-Wold. At the back is the bottle of herb vinegar, in the wrapper that belongs to the wine bottle from Venice.

'In this watercolour I had the idea of mixing objects of two primary colours – yellow and blue – and then pulling it all together with the colour they of course produce – green. It's a painting in which the objects and their colours are of equal importance. In other words, they have two reasons for being placed together. I introduced only white flowers – daisies and pinks, with a bit of ivy from the garden – so that there was nothing that fought with the principal colours.'

Against the greens and greys of the plain back-ground, the objects are tightly grouped on the rectangle of a chopping-board, which is itself framed by three clearly seen sides of the table-top. The artist likens this geometric arrangement to those in the still-life paintings of the Italian modernist, Giorgio Morandi (1890–1964), who was so influential for many English artists of her generation. Morandi's subdued colouring finds echoes in this watercolour, but the comparison is jolted by the splash of sharp yellow, a typical Pamela Kay touch, which makes the lemons the focal point of the composition.

At the foreground end of the composition's principal diagonal, the golden rim of a small porcelain cup is discreetly painted with immense skill. We have seen this rim equally well depicted in the oil of *Preserved Oranges and Basket of Apples*, and comparison of the two demonstrates the artist's versatility in the two mediums.

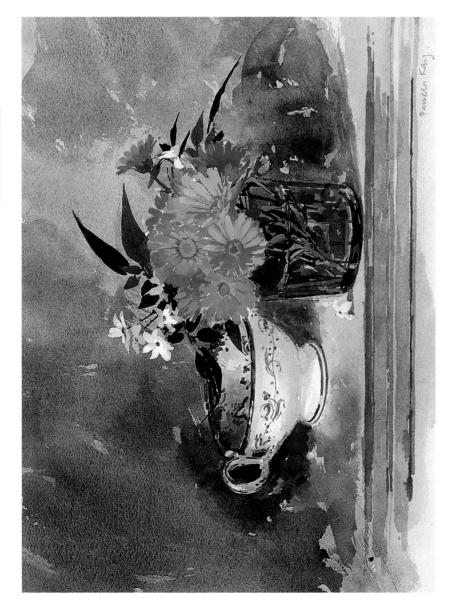

Marigolds, Jasmine and Victorian Cup
Watercolour, 1991, 9x12in (23x30.5cm)

'Yellow is a very hard colour to handle in watercolour. You can at least go piling it on in oil. But in watercolour, if you can't keep it totally transparent and have to go to thick body-colour, then you lose a lot of luminosity. When compared to the previous oil painting, these marigolds did lose some. Also in the green glass is summer jasmine, and there is a little Victorian cup alongside. What I like most about this water-colour is the belly of the cup. It virtually painted itself; it went on in one wash and stayed nice and clean too.'

If luminosity is slightly lacking in the flowers, this is more than compensated for by this luminous passage of porcelain painting. The briefest con-tact of the wet brush has caught the reflected light from the table and glass, and conveyed the inner light that is a property of bone china. As if to prevent distraction from this rarest of washes, the surroundings of this simple still life are vague enough to give it the feeling of a study rather than an exhibition piece. We are shown only the essence of the subject.

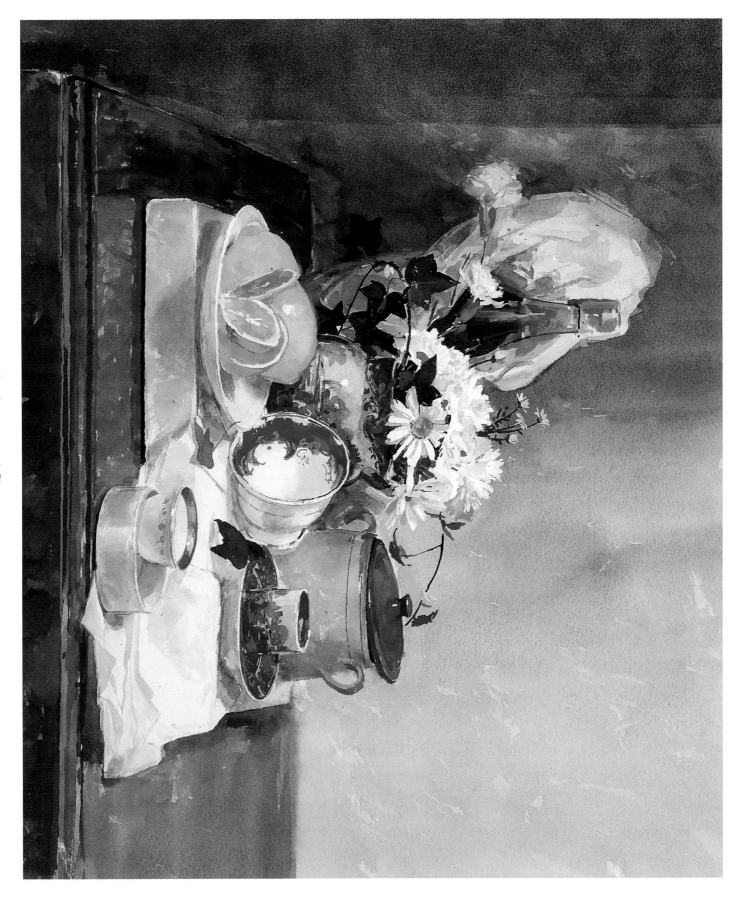

Cut Lemons and China
Watercolour, 1991, 18x18in (45.5x45.5cm)

73

The plums are in a little basket from Cyprus, which is very light in tone. Because the basket-work is open, the contrasting colour comes through the slats, and the straw is a good excuse to draw some angular lines, which contrast with the curves of the flower stalks. The simple glass holds a Madame Pierre Oger rose, some summer violas, sweet pea and a little climbing rose, which is probably a Cécile Brunner.

'Behind the flowers is my favourite teapot

inside the cupboard, which is itself on top of a Scottish dresser. Being able to move one piece of furniture onto another to get different arrangements is rather like changing scenery in a theatre. The frame of the glass cupboard door makes a good vertical and horizontal, framing what is almost a painting within a painting. Slightly mysterious things half-hidden in a cupboard can be more interesting than if they are simply placed on a table. Also, you get a darker tone, which gives quite a lot of recession within very little depth of

field. The physical depth of this group is only about a foot, but within it there is enormous variety.'

The stage set is similar to that used in the painting of *Plums in Terracotta Dish and Teapot in a Cupboard*. The basket has replaced the dish and some of the flowers have been changed. Pamela Kay's observant Naturalism, bestowing dignity on the simplest object, helps us to notice such changes and to appreciate that we are looking at a new image, with a new personality. The cupboard door has also closed, creating a new geometric composition, sharpening the division between light and shade and intensifying the light shining on the plums.

Judicious use of straw, chestnuts and the startling glow of the apple suggest autumnal fruitfulness and harvest suppers. Closely related warm colours reinforce this impression: from the chestnuts, the hard, shiny glaze of the tall casserole and the deeper colour of the olive oil, through the similar tones but cooler colour of a pewter plate, to Mr Ottiger's high-keyed bread-rolls. The whole carefully balanced arrangement is firmly and centrally placed on one of the artist's favourite old chopping-boards, on which radiates the glowing apple. Pamela Kay:

'This apple comes out very late in the year and this one was left for a long time, having already been painted in another picture. It had ripened to this deep, burnished orange colour, almost like amber, and was just the right colour to go with all those browns and greys, for which it is a beautiful foil. There is a pink in a glass at the back, and some blond, pinky eggs, that seem to go with the bread, the olive oil cork and the handle of the knife. These are really very subtle colour changes, but they all matter and give the apple its full value.'

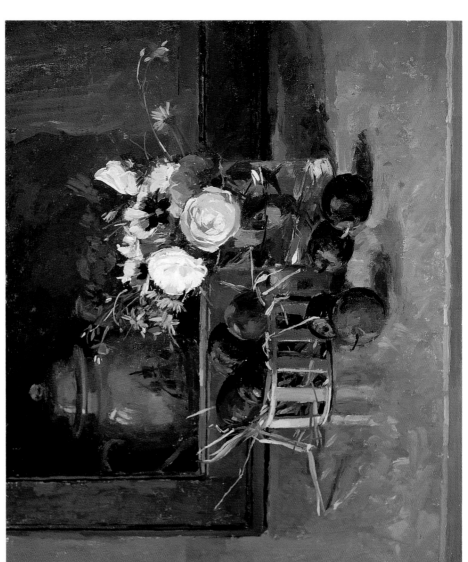

Plums and Summer Flowers in front of a Cupboard
Oil on board, 1991, 12x14in (30.5x35.5cm)

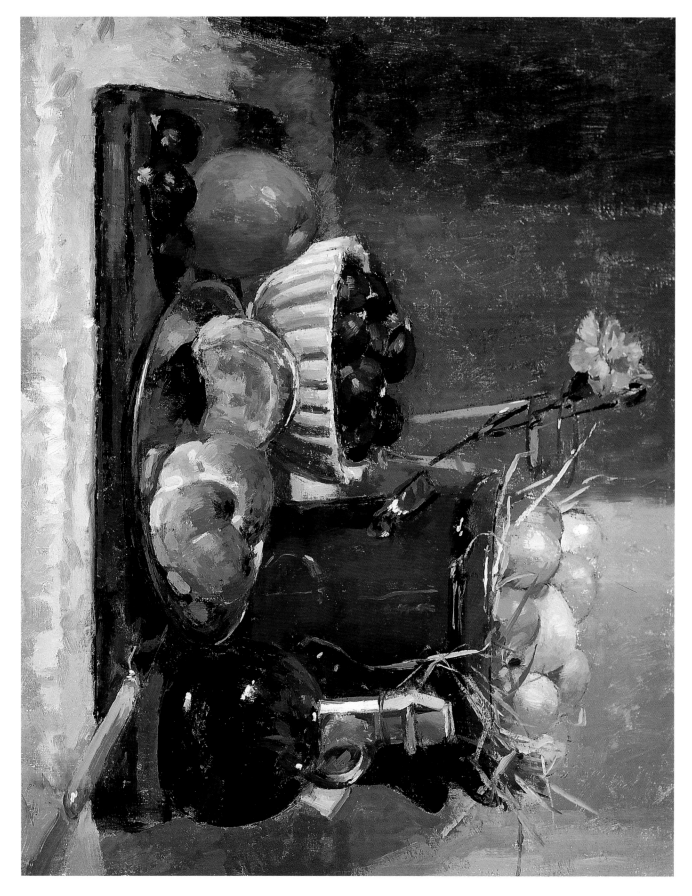

Casserole of Eggs, Chestnuts and Ripe Apple
Oil on board, 1990, 12x15in (30.5x38cm)

75

painted not as some bent green line linking jug and flower-head, but drawn with purpose and direction, to portray the enormous relative strength it really does carry. Light and shade play over the bunch, bringing the nearer flowers forward and making the ones at the back recede.

The artist has first washed in the background, then worked forwards, first painting in the darker stalks in transparent paint and then using body-colour for the lighter stalks and flowers. Building layer upon layer, using broken brush-work to avoid any solid areas that would dull the sense of springing life, she finally achieves this animated portrait of the ox-eye daisy.

The daisy bunch plays a crucial off-centre role in the composition, which ought not to satisfy, but somehow does by balancing darkness and activity with light emptiness. Drawing the larger spaces together is the curving sweep of the still life, sweeping down to a point on the right-hand side, getting smaller and lighter as it goes. And at that point a single ox-eye daisy sits quietly in a small glass.

OPPOSITE
Ox-eye Daisies and Summer Fruits
(Detail)

Ox-eye Daisies and Summer Fruits
Watercolour, 1991, 21x28in (53x71cm)

'This large watercolour shows a basket of strawberries, the Leeds creamware dish heaped with cherries, a Shaker box, a single Madame Pierre Oger rose and a Habitat green glass jug of wild marguerites. These are the real ox-eye daisies, not the marguerites from the garden, which tend to be very stately and still. These particular ones were culled from the roadside outside Elham, near Folkestone, on my way to see a friend. Ox-eye daisies are very delicate and move about a lot more than marguerites, making graceful, arched shapes. They also have much more variety of size: some are closed, some are half-open, some are fully-open.'

Pamela Kay has managed to convey these qualities in a *tour de force* of her watercolour method. The bunch of daisies is shown against a vigorously washed background that changes tone halfway across and thus, through counterchange, gives a sense of change and movement to the flowers themselves. The bunch itself is alive and forcing itself into three dimensions: the volume of space within is virtually tangible. How is this achieved?

Each flower-head is individually seen and individually described, and faces out from the centre as if touching the circumference of an invisible sphere. Radiating out to these points, each stalk is

broken-brush background, while the body-colour in the white areas is more clearly seen than usual and the purity of the cloth is slightly tainted. This said, Pamela has used the paper's tone to full advantage in the economical handling of the basket, glass and flowers, which are all well described.

'I used the toned-ground Ingres paper just for a change, because I hadn't done it before. It had a whole new effect which I like. Having middle-toned ground means that the whites take on a whole new character and the mid-tones in the white flower are even lovelier. If they are semi-transparent you can pick up a touch of the ground underneath, and it's surprising the effect that has. It's nice to discover something new and to realise that you are a student for your whole life. I like being a professional student.'

'Again we see the cup from Chipping Campden. The jar of oil is the one that came from a shop by the Campo, in Siena. It changes colour, depending on where it's placed. In one light it can be like dark amber, and in another an incredible green, like here. I also like its alchemical shape and the label up the side.

'Because it was winter I put some miniature roses in a jar with winter jasmine and pinks to go with the neutrals of the white currants, which came from the freezer. Essentially the picture is based on a yellow-blue-green theme, with the green, of course, being a product of the other two colours.'

Kent Cob Nuts in a Shaker Basket and Pinks
Watercolour, 1991, 7x9in (18x23cm)

Next to a Shaker basket filled to overflowing with Kentish cob nuts and a single damson, is a glass with pinks and a Michaelmas daisy. Unusually for the artist, this small watercolour is painted on toned paper. Such paper allows the watercolourist, especially one using body-colour as her staple medium, to work in a method very different from painting straight onto white paper.

The paper establishes a mid-tone, from which the painter can work lighter and darker, with assured confidence in the evenness and permanence of that tone. The more variegated effect of a wash-ground placed on white paper is less certain, although it allows for more flexibility.

Here the effect of the paper has been marked, changing the character of the characteristic

The triangular composition and colour scheme are simply stated. The colouring is controlled, yet strong in its harmonies. This watercolour is indeed an opportunity to appreciate the discipline of Pamela Kay's still-life work. Every line, every shape, every colour balance and every tonal relationship: each is chosen and specified as much with the head as the heart.

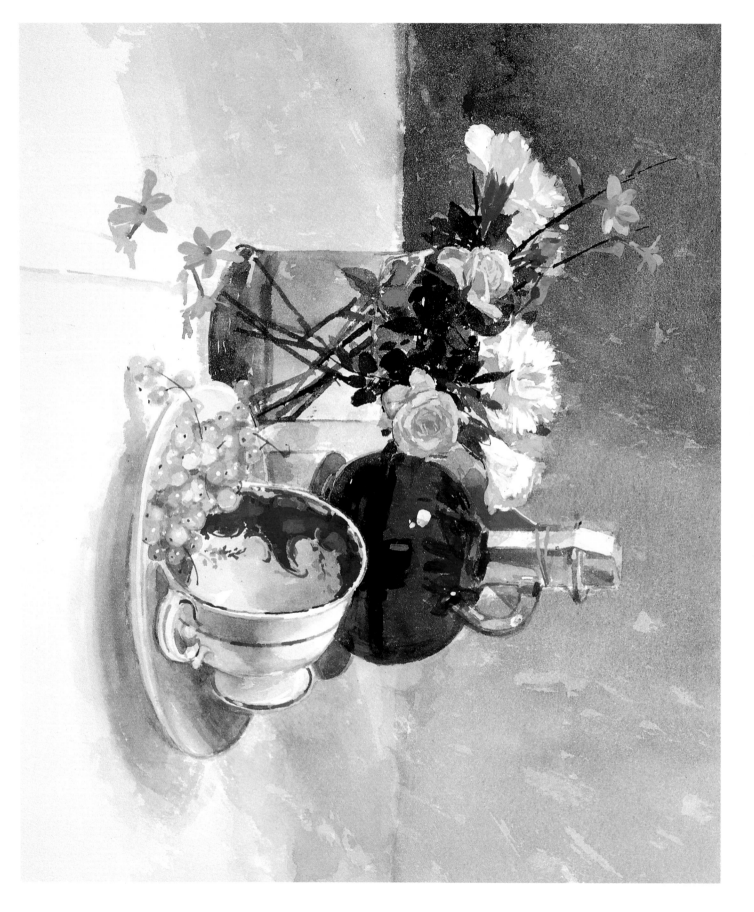

Spiced Olive Oil, White Currants and Flowers
Watercolour, 1992, 13x15in (33x38cm)

79

painting: in the pansies and the plums. The narcissus twitter and sparkle in just the right places to stop the gillyflowers becoming too heavy and clotted with colour.'

The very different blooms in the second painting convey a greater sense of movement, the brush-work is a touch more animated and the grey screen has turned the colour of a thunderstorm. Pamela Kay explains:

'This painting was grim. I made an enormous mistake and warn against painting these delicious *petits fours* when on a strict diet. It was quite painful having to stare at them for some time and feeling an unnecessary hunger. Unusually, these were fresh cakes too. I normally use the same ones I have had for years, so these were available and, I have to admit, were eaten the minute I had finished.

'This is really quite a wild group compared with the gillyflowers. The tulips are quite obviously desperate to escape from the glass and the other flowers have an air of quiet rampage about them. The cakes echo the colours of the flowers and help to move colour around the surface, keeping the eye interested.'

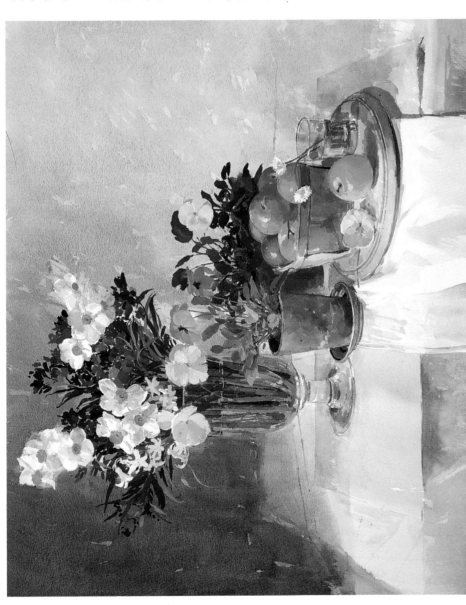

Gillyflowers, Pansies and Punnet of Plums
Watercolour, 1992, 18x22in (45.5x56cm)

A pair of large, rich watercolours rounds off the series of still-life paintings. As may have been noted, the distinction between still-life and flower paintings is sometimes subjective, and these two ease us into the following series of flower subjects. Specially painted for this double-page spread, their individually cohesive compositions echo each other.

The cool, early spring light bathing the complex arrangement of flowers in the first subject picks out every detail with great clarity. All the

variety of colour and texture is managed into a rhythmic diagonal sweep. The accent on orange is thanks to the artist's florist:

'Mr French called and asked if I would like some gillyflowers. I have always thought of wallflowers by their Tudor name and prefer it, as I've never managed to get mine to grow on a wall. His are always early, so I was pleased to have them and arranged this sedate group with an eye to repeating the varied reds and oranges throughout the

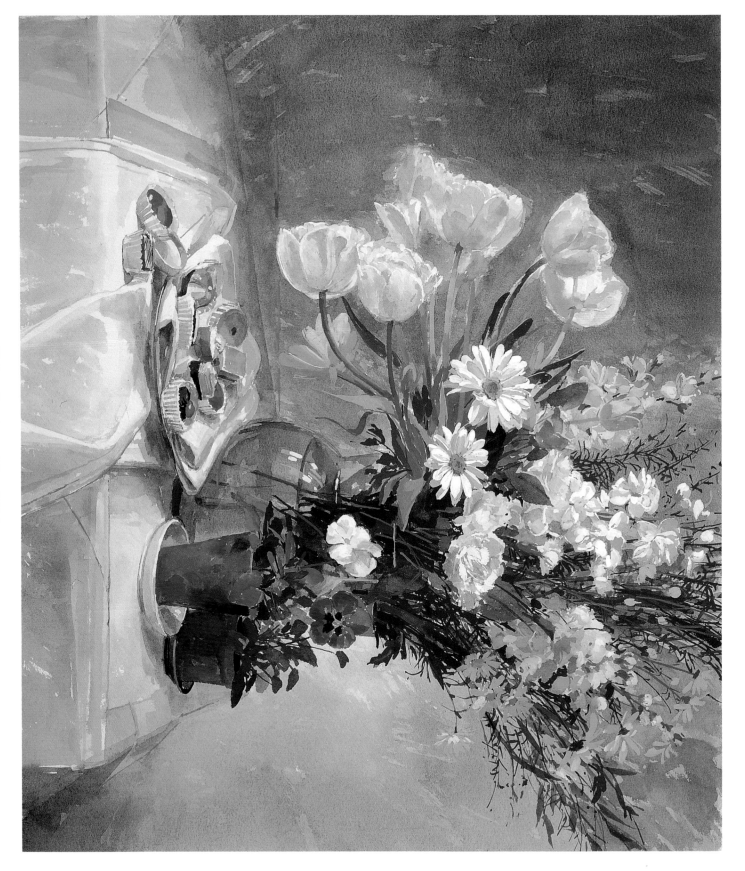

Tulips, Pansies and Small Cakes
Watercolour, 1992, 18x22in (45.5x56cm)

FLOWERS

The following illustrations concentrate on Pamela Kay's ability to capture in paint the life of flowers. The starry galaxies of flowers in these first two works call to mind the floral celebrations of Jan Breughel, as the artist explains:

'There is a fantastic Jan Breughel in the Rijksmuseum of a bucketful of flowers, which may have been an influence, although that didn't occur to me at the time I did this. This is a modest offering by comparison.

'The flowers are in a Spode jug and the painting is all blues, purples and whites with touches of pale pink. But the thing that tells is the orange nasturtium, which was needed to pull you up sharp. Of course, nobody would actually arrange flowers like that, with one contrasting bloom; it's just a painter's device. There is a school of flower arrangement which is terribly self-conscious, with strict rules that say that every bloom must have its own space within a pyramid form. I think there is nothing more delightful than a lot of buttercups pushed into a jam jar. Equally, I think flowers that have simply been put in a jug are easier to live with, because they don't convey this strict formalised attitude. Years ago I started off by doing paintings of flowers arranged in the Constance Spry manner. They looked awfully stiff and artificial.

'In this arrangement I like the randomness. I will rearrange a little, but still allow the flowers to do their own thing, because they will move around anyway, following the light and opening up and closing. And soon some will start to drop. This painting was very much a race against time. I think a flower painting only looks good when the flowers start to die, because until then the picture is only a pale imitation of how beautiful they are.'

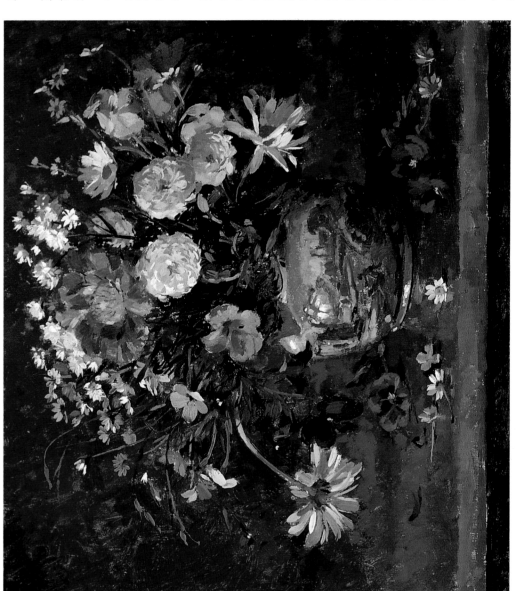

Spode Jug with Pansies, Daisies and Scattered Flowers
Oil on board, 1987, 14x13in (35.5x33cm)

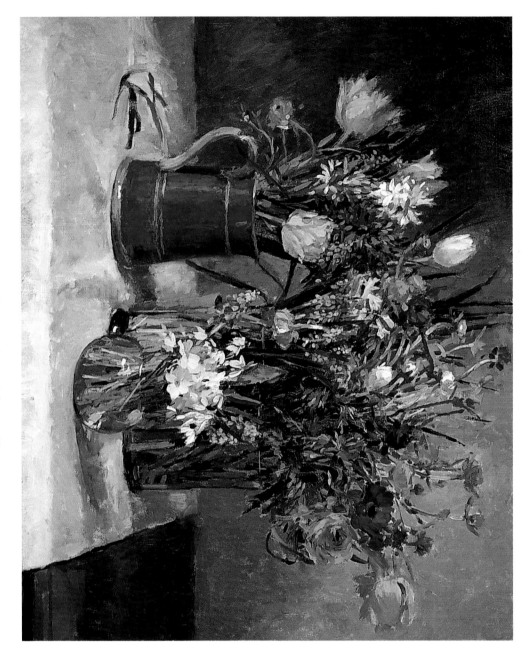

Jugs and Glasses of Ranunculas and Spring Flowers
Oil on canvas, 1988, 16x20in (40.5x51cm)

'I think of this as my Rupert Bear painting. The colours are rather like those in the cartoons by Alfred Bestall, which were quite an influence. I love those very simplified drawings he used to do of flowers: little stars and circles of light. They were done in primary colours that he made go very well together, which is not easy to do. This painting was an attempt to combine the primaries, with the blue Habitat jug and grape-hyacinths, the yellow tulips and the red poppies and ranunculas.

'I love the starry feel of all these coloured flower-heads. They are not arranged and don't follow any particular order of colours. They are simply amassed, and it is the massing of them that is their glory. Because there was such a huge expanse of them I put a glass of primroses in front to break it up a bit.'

Somehow, what seems an inordinately complex floral arrangement is clearly described. Freely and rapidly painted on a fairly small canvas, every leaf, every petal, every nuance of colour, light and shade is revealed with the clarity, if not the detail of a botanical drawing. To imagine how difficult it must be to do this while the flowers live is to comprehend why some Dutch flower painters worked from drawings.

'In the glass is a clump of what I call "wedding cake", although that is not its proper name. It's a lovely little rockery plant that actually grows wild, by the roadside, on the Thanet Way. I picked quite a lot of it, pulling it up by the handful with its roots attached. I decided to put some in the glass so that I could paint the roots, which were a delicious brown, slightly peaty colour. I think the roots and stems are every bit as interesting as the flower-head.'

This view, perhaps unconventional for a flower painter, though not for a botanical illustrator, is amply justified by this pretty watercolour. Using a very limited palette, with only the bunch of feverfew on the tablecloth to distract us, the modest beauty and delicacy of the stems and roots is given its say. As in the large watercolour of *Ox-eye Daisies and Summer Fruits*, the changing tone of the grey screen balances the light and shade on the 'wedding cake'. Here the counterchange is more pronounced, with the lit left-hand side of the plant standing out against the dark wash, and the shaded right side against a lighter background.

'On this table-top are a round and a straight glass with an apricot rose and some marigolds and other flowers, and a beautiful little basket in very high key, containing peaches. The biscuit in the foreground is from Madrid, and came in the little box to its right. All the colours are keyed to the apricot-coloured rose, so are very blond and slightly apricot in cast. The blue-grey of the background acts as a neutral foil to point up the apricot colouring.'

Like the watercolour opposite, this is painted with a very restricted colour range and subtle tonal changes, which confer a restful poise on the arrangement. This sense is further enhanced by the larger geometric areas of the picture, which are balanced across each of its axes.

Wedding Cake and Feverfew
Watercolour, 1988, 17x13in (43x33cm)

Basket of Peaches, Biscuits and Two Glasses of Flowers
Watercolour, 1988, 18x21in (45.5x53cm)

was done, the artist must have worked at great speed to capture every buttercup before they dropped. She has managed to produce a group of individual buttercups, rather than a bunch of buttercup-like flowers, with a few foreground ones detailed for reference purposes.

This is another flower painting from the series, painted in the autumn, with spray chrysanthemums and vine leaves in the background. As the vine turns colour in autumn, the leaves go this wonderful coppery green. On the right are some Michaelmas daisies that have gone to seed and make lovely little grey puff-ball seed heads.

'I used to have an allotment up by the cemetery. There was great camaraderie up there, and dear old Tom used to grow these spray chrysanthemums in the allotment next to mine. He protected them from the wind that whistled straight off the North Sea by erecting what he called his Berlin Wall of sacking around them. So against the odds, he managed to have a marvellous crop of chrysanths for sale.'

There is a feeling of weather within this watercolour. The artist seems to be encouraging us to imagine that the setting might be outdoors, rather like the landscape backcloth to a portrait by Gainsborough. The screen has now darkened on both sides, as though it is coming on to rain.

Set off against the greys, the abundant chrysanthemums carry the colours of autumn and provide a fitting contrast to the yellows of the earlier summer flowers opposite. This work is now, appropriately, in a collection in Japan, where the chrysanthemum is the national flower.

Buttercups and Daisies
Watercolour, 1988, 20x24in (51x61cm)

'This is an enormous bunch of buttercups, ox-eye daisies, cow parsley and, just for a touch of warmth, there are a couple of orange poppies in there. They were sitting in three old sweet-jars, which had good depth for water. The jars were arranged one behind the other on a table, so that all I could see was a mass of foliage. I was standing with the flowers just below eye-level, so the jars would be just below the edge of the paper. Behind the flowers is the grey screen and the shadow was cast to the right. It was very useful to have the dark, arching stems of the daisies and the cow parsley against the light side, and the light daisies on the dark side. It makes for variety.

'This is a huge summer watercolour from a series that I did. They tended to addle my brains a bit, so the series was a fairly short one. I would paint the flower-heads first to get them in before all the petals dropped off, and had to look very carefully to get them all in the right places. At the end of the painting, after about a week, all the heads were absolutely naked – a lot of stalks sticking out of the jars and a great shower of gold on the table-top.'

This is a natural-looking arrangement, although one suspects that the relative positioning of the cow parsley and daisies was more than just good fortune. Once the 'casual' flower-arranging

Chrysanthemums and Vine Leaves
Watercolour, 1988, 25x35in (63.5x89cm)

only a brief moment; a moment that is usually shared only with the painter.

'Every year I like to paint buttercups. This all began because of a beautiful painting by Allan Gwynne-Jones that I saw when I was a student. He had painted some kingcups in a jam jar. It was a tiny painting, only about 6 by 8 inches, but I had never seen yellow painted so that it resembled gold in quite the way that he had done.

'Gwynne-Jones is one of the painters who influences me most, although he is sadly no longer with us. His colour and his tone, and the way he painted things, were so modest and so truthful and so pure. And he was, of course, a brilliant draughtsman. It is no good thinking that if you know about colour you can paint anything. If you cannot draw as well, you have only got some of the ingredients for the whole cake. Each ingredient is vital, and he had the lot. It's just tragic that he went blind. So in a way I always like to paint buttercups as a tribute and to remind myself every year of Allan Gwynne-Jones, because he showed them to me.'

This oil is effective both as a tribute and as an example of Pamela Kay's dictum that flowers in a jam jar can be as beautiful as any arrangement in a china vase. The jar allows the artist to indulge her pleasure in painting stalks in water and also has the benefit of being an extremely familiar shape. We all know so well what a jam jar looks like that we can read the shape of this one from the few highlights and touches of shade which we are given. Meanwhile, the yellow flower-heads that Allan Gwynne-Jones showed to this artist shine from the dark ground.

Blue Mug with Orange and Yellow Flowers
Oil on board, 1987, 13x14in (33x35.5cm)

'This is a Habitat mug: we saw a jug from the same set in the larger painting of *Jugs and Glasses of Ranunculas and Spring Flowers*. It is an unusual cobalt blue, which I hadn't come across before. It's not quite the same blue as the Spode, for example, and is the perfect complementary colour for marigolds and nasturtiums, or indeed any orange flowers. Here the orange flowers are interspersed with daisies and other white flowers,

but I felt that it was possible to give the whole of the painting an orange cast because the mug acted as a beautiful foil.'

The flowing, liquid brush-work hints at the speed with which Pamela must have worked to capture these very delicate and unstable flowers. Of all Naturalist genres, the flower picture is unusual for being comparable with its subject for

OPPOSITE

Buttercups in a Jam Jar
Oil on board, 1990, 14x13in (35.5x33cm)

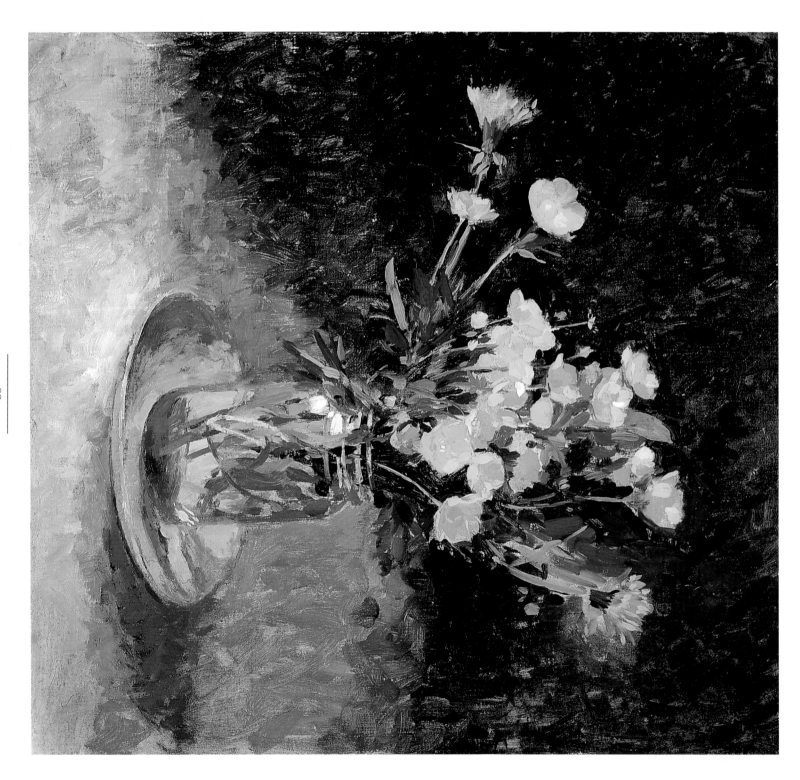

In other hands copper painting in watercolour frequently has a lifelessness born of the intense effort of the task at hand. Here there are no very specific reflections and the artist has been careful not to overwork the brush, thus preserving the luminosity of the paper. The simple orange washes are a complementary match for the green of the pansy leaves.

'A friend who owned a gallery in Sandwich had an oblong copper dish planted up with pansies, and it looked so beautiful. You don't really expect to find pansies in a saucepan, which doesn't have the same sort of elegance, but I thought that was a pretty good reason for painting it. Anything that pulls you up sharp and makes you think a bit is not a bad thing.

'The colours of the copper were so beautiful: lilacs and raw sienna – not at all what you would expect, which is the best reason for painting anything. With copper I start with the lighter colours first and then work towards the darker ones. I step warily, but if I do make a mistake in the lightest colour I can usually correct it with a wash over the top. If it has gone too far I will use some body-colour. If I don't get it in transparent water-colour, I shall jolly well get it in body-colour!'

Here I have placed the cup we saw in *Marigolds, Jasmine and Victorian Cup* next to a glass of early summer flowers: a primrose, an early marigold or two, some wallflowers and bellis daisies.

'I think a point about watercolour is that you really can make something out of the simplest objects. It really doesn't take much to make a pleasing painting. This is just a beautiful cup and a very simple glass, in which you can see the stems of the flowers to get the full pleasure of them. The light is pleasant and the cup has the same beautiful cream colour as the primroses and the wallflowers, providing the key for the colour range.'

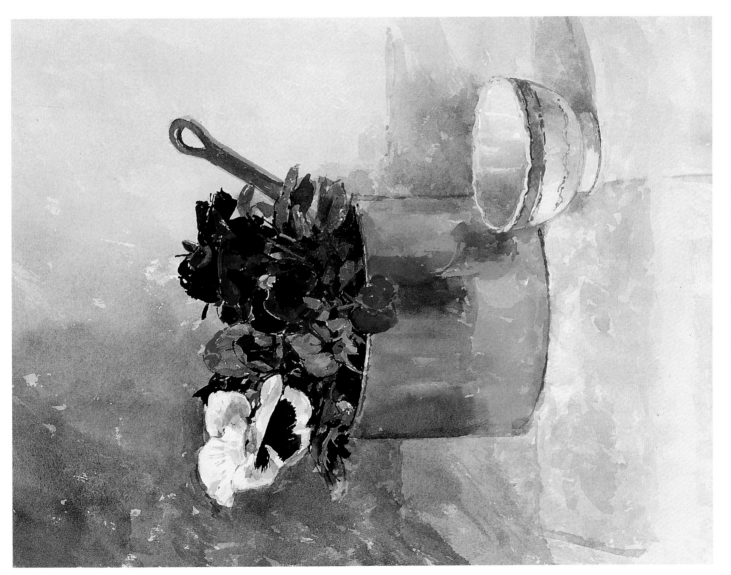

Pansies in a Copper Saucepan and Tea Bowl
Watercolour, 1989, 13½x9½in (34x24cm)

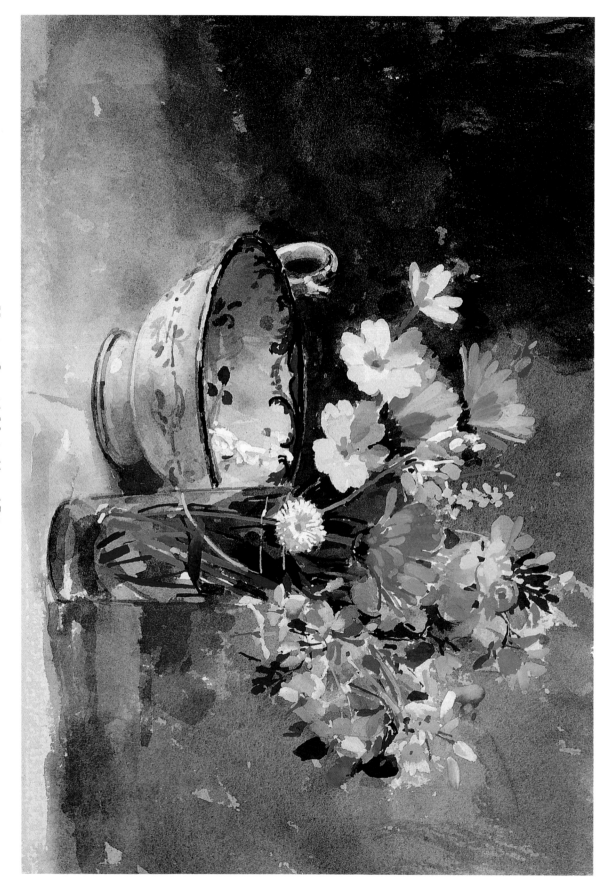

Victorian Cup with Marigolds and Primroses
Watercolour, 1990, 7x9½in (18x24cm)

He looked at it with great intensity and said, "Yes, I remember that one. I really worked at that". It was a densely packed pencil drawing with a light wash on it and you could see that he really had worked his way round each petal. And it was definitely worth it. Some people decry the painting of roses. They think of old ladies and small paint-boxes and are very sniffy about it. They don't realise that it is one hell of a challenge. You don't have to like doing it, but I thoroughly enjoy it.'

The quartering of the centifolia which Pamela mentioned is clearly visible in the large pink Fantin-Latour rose in the glass on the right of the other watercolour. In the jug is a smaller, slightly faded Fantin-Latour and some climbing Cécile Brunner roses, together with forget-me-nots and clover. The symmetrical composition of this watercolour emphasises the differing characteristics of the flowers, while a line of three beached nap cherries relieves the symmetry and acts as a foil to the verticals in the composition.

'The jug is Victorian, with a nice barley-sugar twist, which is quite difficult to paint. The twists take the eye down to the cherries at the base, which, although they are necessary to the composition, weren't consciously put in for that reason. I only realised what a useful device they were after I had finished the watercolour, and wouldn't have brought them in later, even if I had wanted to. The arrangement has to be complete before I start, and if it is not, I can't put brush to paper. If I altered anything half-way through, all the relationships would change and a lot of effort would have been wasted.

'It's not a matter of having a vision of how the picture will look, more an instinct of what looks right. I know instinctively what does work as an arrangement, but I can't know what I am actually going to arrive at until I have put it all together. I can't race ahead of it, but I can tell you when it's right.'

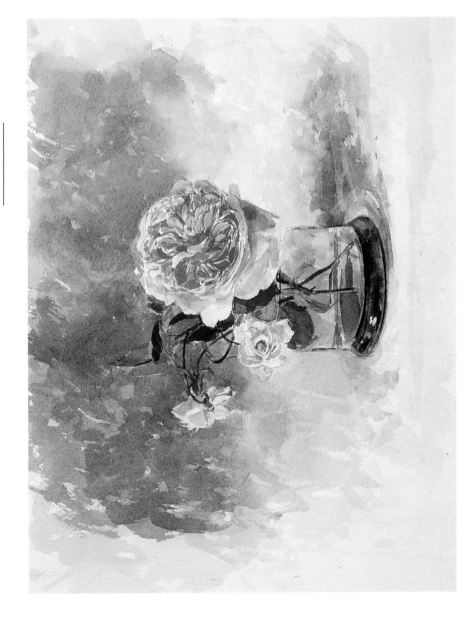

Pink Centifolia Rose
Watercolour, 1991, 9½x11in (24x28cm)

This simplest of arrangements may fairly be called a study rather than a finished painting. Not that there is any lack of finish, but the artist has poured most of her considerable concentration into the depiction of one exquisite and complex flower-head. The careful painting of the glass and a soft background are almost forgotten as we indulge our senses in the brilliant luminosity and faithful detail of this rose.

'Eileen Pritchard, who publishes cards of my pictures, gave me this rose, and this is the first flower from the plant. It is an old-fashioned centifolia from David Austin, who supplies many of the roses I paint. They have much more interesting shapes than the modern roses. This one is what they call an English rose, bred specifically to have a recurrent flowering, and so has the edge on the Fantin-Latour. It is a particularly beautiful rose, with all the best qualities of the centifolia, with the quartering and the packed mass of petals inside a cup. If I had a much bigger garden I would fill it with roses like this.

'I remember once watching John Ward peering at a study of an old-fashioned rose that he had painted some years earlier and sold to a friend.

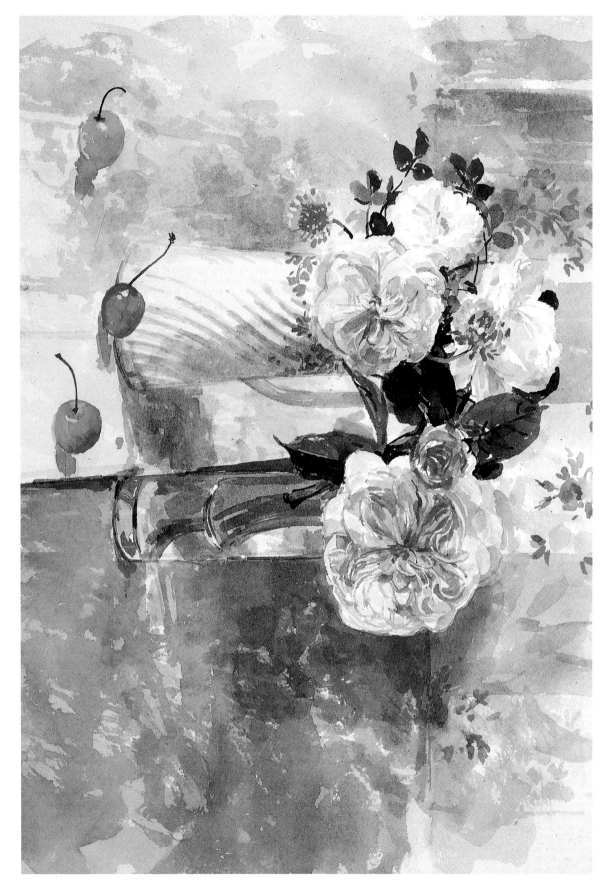

A Glass and Jug of Roses and Three Cherries
Watercolour, 1989, 8x11½in (20x29cm)

'This is a tableful of flowers: violas and hyacinths, with the main pots of ranunculas from Mr French. Only recently have the Dutch been producing mature, fully grown and flowering ranunculas in the early part of the year, which is marvellous. The market is expanding and becoming much more imaginative, which is very much to my benefit as there are many more plants I can make use of in my paintings.

'On the right, behind the glass of primroses, is a reproduction Shaker box from Habitat that I used before I got a proper one. I put plant-pots in this picture to give more variety than if they were all painted in terracotta pots, which might be boring. The violas I planted in coffee-cups and then, after I had finished the watercolour, took them out again and resuscitated them. Doing slightly unusual things like this means that people will perhaps look twice.'

This arrangement is less ordered and tiered than the serried ranks of English spring flowers in the watercolour opposite. The more sinuous flowing stems and blooms suggest, as does the fruit on the table, a summer still life. Yet there is something – whether it is the cool light or simply that we have been let into Pamela's secret about the Dutch ranunculas – which suggests March or April. Perhaps it is that tell-tale hyacinth!

'This was painted with similar ideas in mind, the next January or February, which are my most desolate months. Because they have to stand up ferociously straight to withstand the weather and the snow, spring flowers are very rigid. They don't have the grace and lovely wandering quality of daisies and buttercups. That is a bit of a problem for me, but I do the best I can.

'This is a whole table-top of spring flowers. I arranged them in tiers, so that I could have a nice cascade of blooms. It's a bit like a football terrace, and they were all watching me as I worked on the football pitch! The miniature narcissi at the back are in pots, which is useful, because they have quite a long shelf-life. On their left is a hyacinth and then in front bellis daisies, also in pots. The Habitat mug appears again and a little blue-and-white Hilditch cup, which we found in an antique market in Stratford-upon-Avon and which has a beautiful blue Chinese pattern. On the right is some *Soleil d'Or*, cut short, in a very deep-blue glass. The yellow against the blue is the keynote of the painting and is echoed in the blue arc swinging down from the left against the yellow arc on the right of the painting.'

Anyone who loves spring flowers will appreciate how accurately Pamela has caught them, and how her incisive drawing of the stems works to reveal the rigidity to which she refers. She has also made use of the still poise of the narcissi to explore the intervals between the flowers, an effect which is picked up in the starry row of bellis daisies. The artist may be pining for summer days, but the viewer is not disappointed.

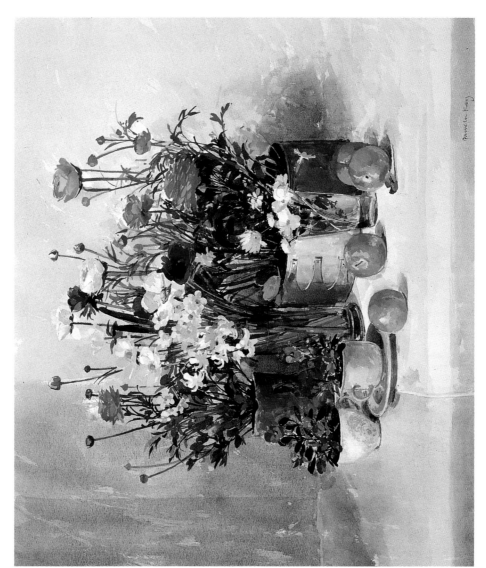

Ranunculas, Violas and Golden Plums
Watercolour, 1990, 18x22in (45.5x56cm)

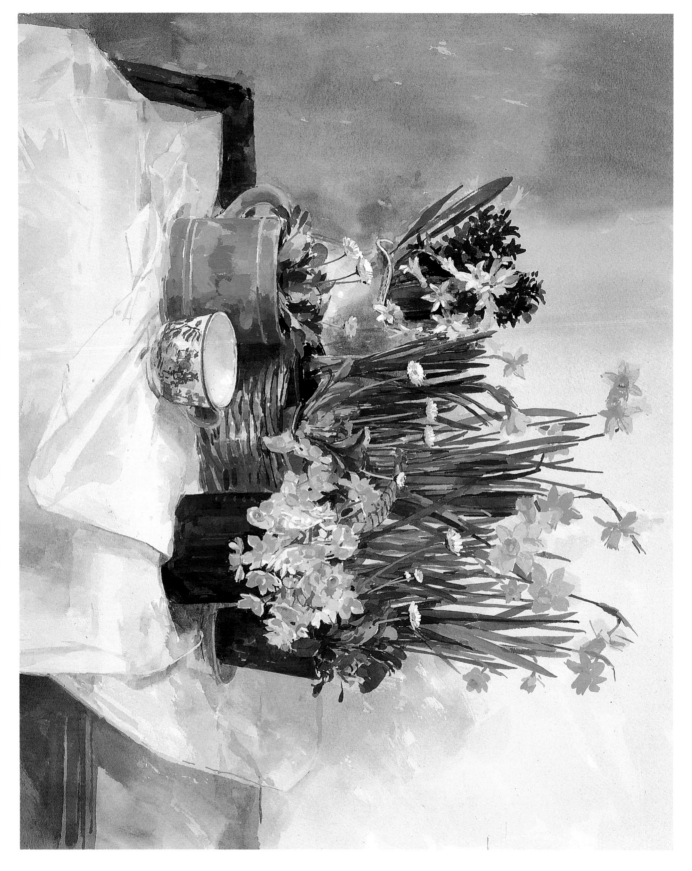

Table of Spring Flowers and Basket of Daffodils
Watercolour, 1991, 18x22in (45.5x56cm)

Rose Alberic Barbier
Oil on board, 1990, 13x14in (33x35.5cm)

Small, simple in format, and with suitably silken handling, this oil clearly exhibits a precise reading of its luxuriant subject. For example, the incident of light on each leaf is individually studied and characterised, and its colour exquisitely juxtaposed with the creamy flower-heads and the grey background. Pamela Kay:

'This is simply a glass of the magnificent rose Alberic Barbier that will comfortably grow in great profusion on a north wall and has these lovely dark glossy leaves, with a high shine to them. Of course, the leaves of roses vary enormously and each type of rose has its own particular leaf.

'The rose itself is like a handful of petals, loose and not at all structured, as if it were held together by Sellotape at the back. It is beautifully cream in the centre and cream in the bud. Otherwise it is white, a colour I love to paint, and always a joy to paint when it comes out in the early part of the summer.

'The rose is surrounded by neutral colours and one small violet, just for that kick that you need to complement the cream. It's like having a pinch of salt on something to bring out the flavour.'

This informal indoor picnic is the epitome of summer delights: luxurious brush-work describes cloth and rose, together with fresh plump strawberries in a delicate basket, a cup and some biscuits. Yet the painting stops short of being too lush or sickly: an unassuming coffee-cup, the colour of Chinese Celadon-ware sets a note as central tone and reference point between the richness of fruit and flowers and the grey surround. Pamela Kay:

'The strawberries are in a tiny wicker basket, with old-fashioned roses from the garden and a very pretty jade-green cup, which I got in Madrid because it was such a nice colour. Also, there are

Spanish home-made biscuits, quite thick and chunky with some lovely idiosyncrasy.'

The roses are painted with free, if assured brush-strokes, which, through manipulation of colour and tone, give the impression of immense detail. But in truth it is the artist's ability to convey the volume and weight of the flower-heads which enables the viewer to really believe in their existence.

'I look closely at Fantin-Latour. I know he had a very different technique from mine, because he was able to paint a flower piece in a day. But you can tell he would not fully complete them, be-

cause he went back when they were dry to paint glazes onto the centres of flowers, to give them luminosity. Of course, while the picture is drying the rose is dying, so I have a feeling he had photographic help: all his work is tonally so exact.

'I have learnt from Fantin-Latour to look at the heart of the rose first, then to look at the light on it and think of it as a tea-cup rather than as a flower, because a lot of roses are concave. There is a temptation to try to describe the petals in dark tones, simply to make the drawing show. But this defeats the object. I learned from Fantin-Latour that the most descriptive centres of flowers are done with remarkably close-toned painting. He only painted what needed to be painted.'

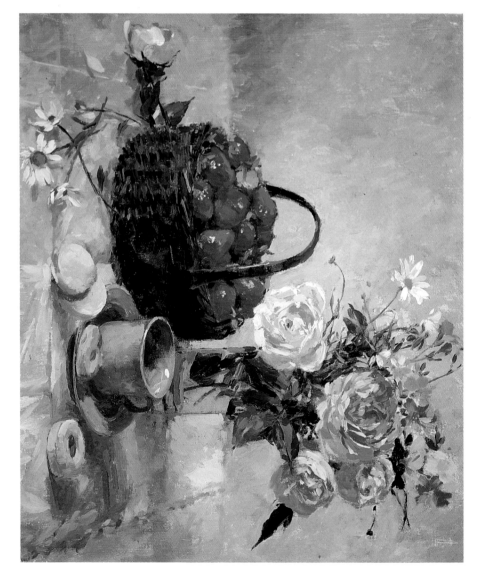

Basket of Strawberries, Biscuits and Roses
Oil on board, 1988, 13x14in (33x35.5cm)

If the artist had to move fast to catch a couple of wilting blooms in quick time, this complex display of over forty vulnerable flowers must have made for quite a race. It would have been so easy to have sketched in the blooms, but they needed individual identity to hold their own and to hold the whole together. What enables Pamela to create the desired variety within the sweep of flowers is the handling of patterns of light and shade.

'I particularly like ranunculas because they remind me of centifolia roses, even though they are of the buttercup family. The complex layering of petals and the stems like swans' necks, ending up in a mass in that big green jug, make them an enormous pleasure to paint. The stems have an eccentric curve and drawing them is like drawing a moving line, thus transforming what could be a very static arrangement. I think the whole thing about flower painting is to make it as alive as possible, utilising every possible artifice to do so.'

[PAGE 100]

A gentle epilogue to the series of interior flower paintings, this little watercolour is a study in subtle changes of colour and tone. The light and shade on the early spring flowers is depicted with extreme care, picking out tiny variations of reflected light and colour.

'The Royal Horticultural Society have a very fine plant shop at Wisley and on my way back from the Cotswolds one time I called in and bought half-a-dozen pots of Christmas roses. Every year I like to paint them because they are the first flowers to appear in the garden and break the gloom of the dark end of the year. They are so beautiful and both the *Helleborus orientalis* and *niger* flower for a long time; hence the primroses. A couple of glasses placed in front of an open cupboard gives the right depth of tone to the background to isolate the flowers.'

Pink Roses in a Creamware Basket
Oil on board, 1991, 10x12in (25.5x30.5cm)

Another lesson in the painting of the rose, the luxuriant charm of this simple image derives from the pearly glaze of the pierced Leeds basket and the foppish splendour of the Fantin-Latour roses from the artist's garden.

'I remember reading about the incredible collection of old-fashioned roses belonging to Humphrey Brooke, once Secretary of the Royal Academy. He said that you should never prune an old-fashioned rose; you should just let it go, and that's what I have done with my rose Fantin-Latour. I bought it because I wanted a centifolia and because of the name. Now we have a rose-bush that is so rampant that we had to put up a chestnut paling for it to arch over. It is a beautiful cascade of pink blooms for about a fortnight, so I have to work fast. Here, in the open-work basket, without water, the roses went very quickly, so I had to work at twice the speed.'

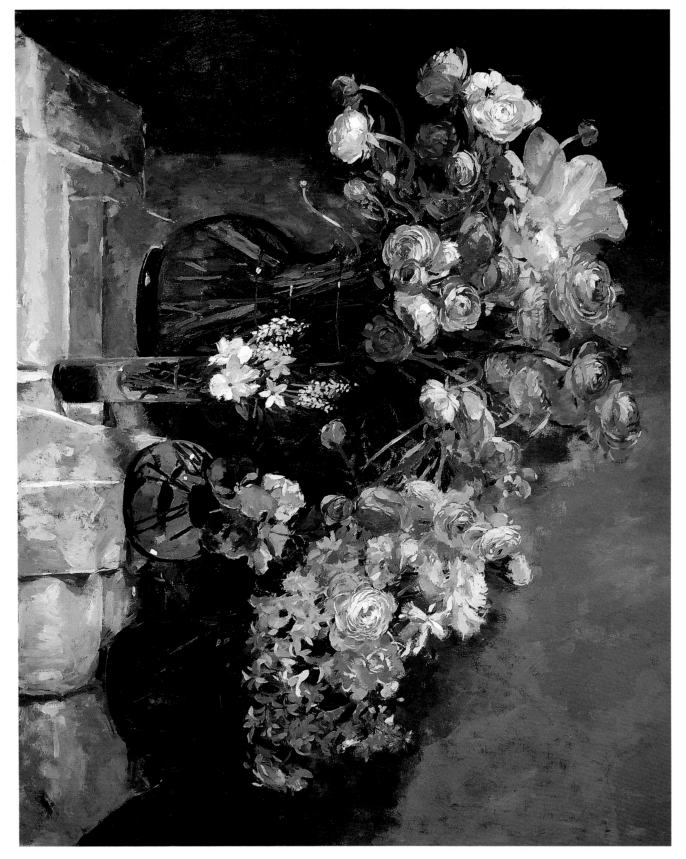

Pink and White Ranunculas and Spring Flowers
Oil on canvas, 1991, 20x24in (51x61cm)

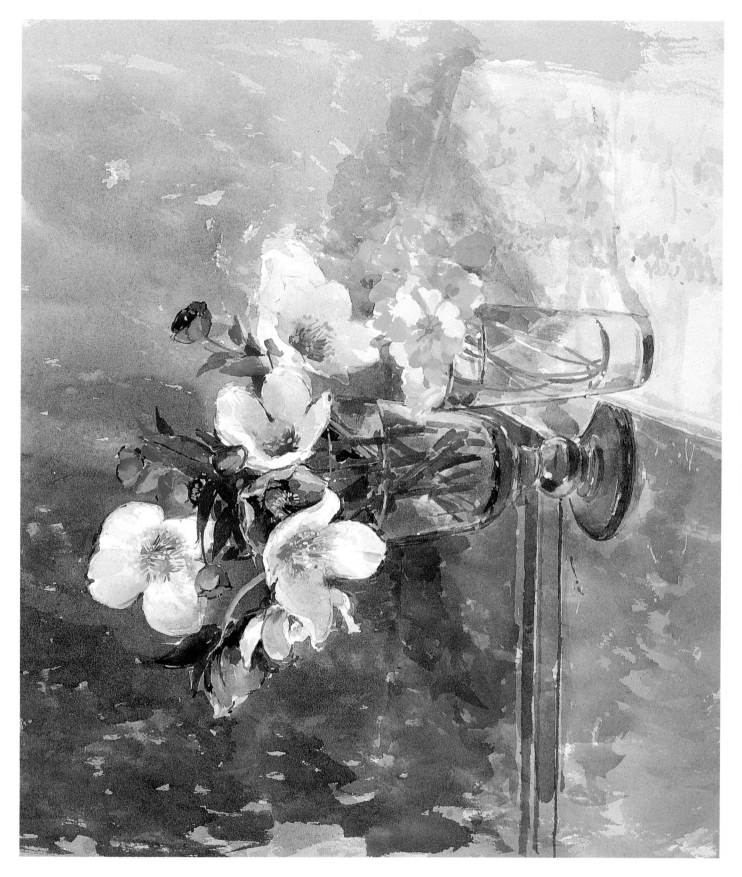

Hellebores and Primroses
Watercolour, 1992, 13x13in (33x33cm)

Now we move outside, briefly to the artist's front garden. She has chosen a couple of square yards filled with diverse plants and seen from above, so that there is no background or horizon and the whole subject comes within her focus. The handling of the complex twists and turns of stems, the mixed and variously angled flower-heads and the subdued patterns of light and shade bring to mind the two large water-colours of large sprays of spring and late summer flowers in jars, which we saw earlier. Pamela Kay:

'There are Icelandic poppies, delphiniums and daisies. The tiny bit of paving stone on the left betrays that I am in the garden. I simply set up the easel and a big umbrella. In a good summer you cannot work with white paper without an umbrella: the glare gives you snow-blindness. So it was a matter of painting what was in front of me, although it moved about a lot when I got a breath of wind. First I placed the main flower-heads, which are the principal focus, and then worked around them to put the greenery in.

'Working in the front garden I had to resist the temptation to chat with all the people who pass by. Everyone around here seems fascinated when they see me painting: they all feel terribly involved and proprietorial. It's a bit like having television on your doorstep – my painting is a spectator sport for the neighbours. But it's nice that they like the idea of having someone like me in the road.

Flower Border and Three Yellow Poppies
Watercolour, 1987, 20x13in (51x33cm)

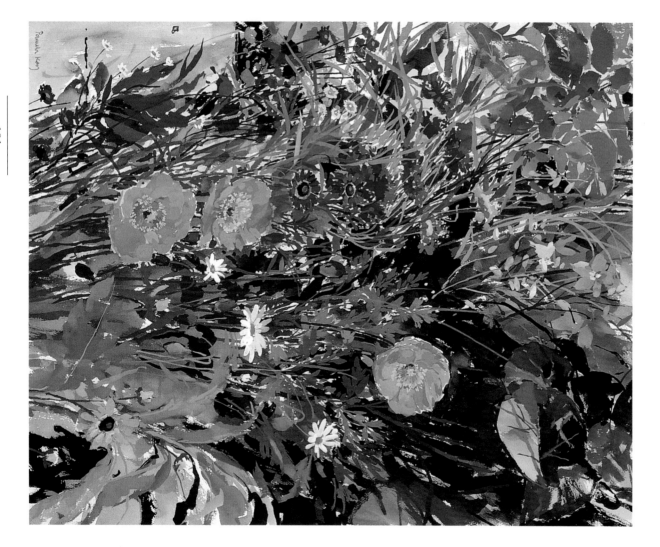

As a rule, Pamela Kay has painted as few paintings of other people's gardens as she has portraits of other people's families. She cites three practical reasons for avoiding such forays:

'First of all, there is a lot to carry: an easel and, if it is sunny or wet, an umbrella. Secondly, if you are going to work in a public place, painting becomes a spectator sport; if you are going to work in a private place, that has to be arranged. The third reason is that I don't take on commissions. So it doesn't happen that often!'

This watercolour shows, at its August best, one of Sir Geoffrey Jellicoe's theme gardens at Sutton Place in Surrey, once the home of John Paul Getty. Under the later custodianship of the Sutton Place Heritage Trust, members of the RWS were invited to paint the gardens for an exhibition to be held in a gallery in the house.

'The Impressionist garden was spectacular, full of Michaelmas daisies and nasturtiums, irises and clematis, in front of this lovely soft brick wall with mullioned windows. To suit the theme the Jellicoes had obviously thrown in every colour they could find, and it worked. Where the wall was in shadow, there were the light tones of these lovely straps of iris leaves, as well as the white blooms of what I think are Japanese anemones, singing away in the dark.'

'This is a classic Cotswold garden of extraordinary beauty. It is behind Chipping Campden's main street and belongs to a delightful lady, who opens it to the public in aid of an autistic children's charity. One Sunday, when the garden was not normally open, she kindly let me sit there to do this watercolour of the steps from the house. At one time I thought of going on to do a series of Cotswold gardens, but, this one excepted, they tend to be just a little bit too immaculate for me!'

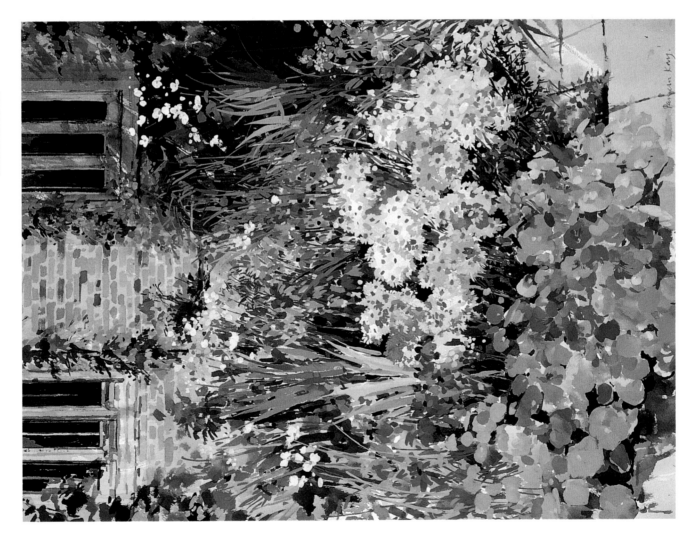

Impressionist Garden, Sutton Place
Watercolour, 1986–7, 27½x20½in (70x52cm)

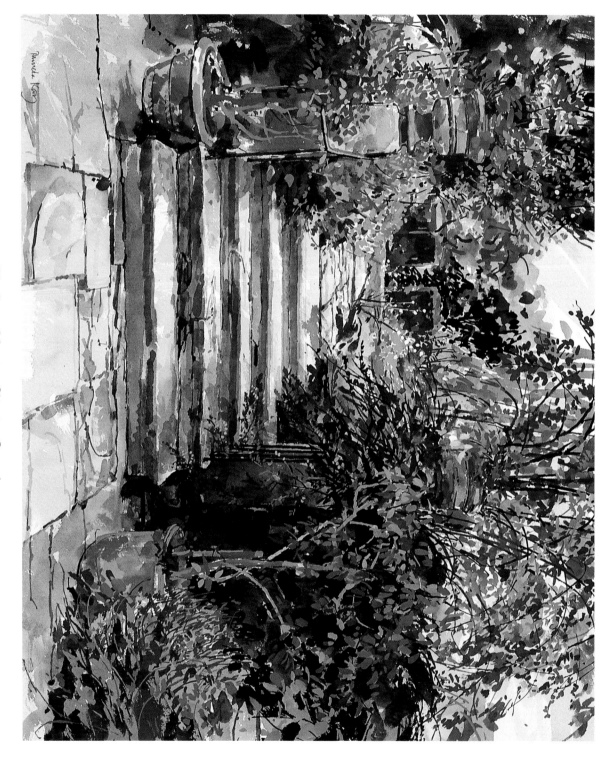

The Steps, Martins, Chipping Campden
Watercolour, 1987, 18x22in (45.5x56cm)

'This is the daisy bank at Goodnestone Park, which Lord and Lady Fitzwalter open to the public under the National Gardens Scheme. By the gate-house is this amazing bank, which gets covered in a beautiful sea of ox-eye daisies. Lady Fitzwalter gave me permission to work there, so I set up by the entrance, with this view up to an arched gateway at the top of the bank.

'Of course, everyone coming into the park passed by me, and painting really did become a spectator sport. Someone even came along and videoed me while I was working, and all that can be a little wearying, unless you have a thick enough skin.'

The swathe of daisies is painted with clarity and, as the flower-heads diminish in scale, serves to give recession to the evenly-toned bank. On the left of the gateway a bluish cast enlivens the warm colour of the wall, which in turn offsets the otherwise unrelenting march of green, white and yellow up the picture.

'I painted this watercolour one April at a private garden near Stow-on-the-Wold, where the wind blows cold, and it certainly did then. I sat there all day, while the wind just whipped up the valley, straight through me and on over the other side.

'I was asked to paint something in the grounds and just left to my own devices, which is the only sort of commission I would do. I chose to paint this delightful naturalised clump of primroses, with lots of little leaves.

'Back in the hotel, with a hot toddy, I was looking at the finished watercolour and suddenly noticed that there was a little owl or ghosty, peeping out from inside the tree. Of course, it was unintentional, although similar things have happened before. I like to think that it is the spirit of the place. I also like to think that this is a very cold painting and gives you a flavour of the temperature.'

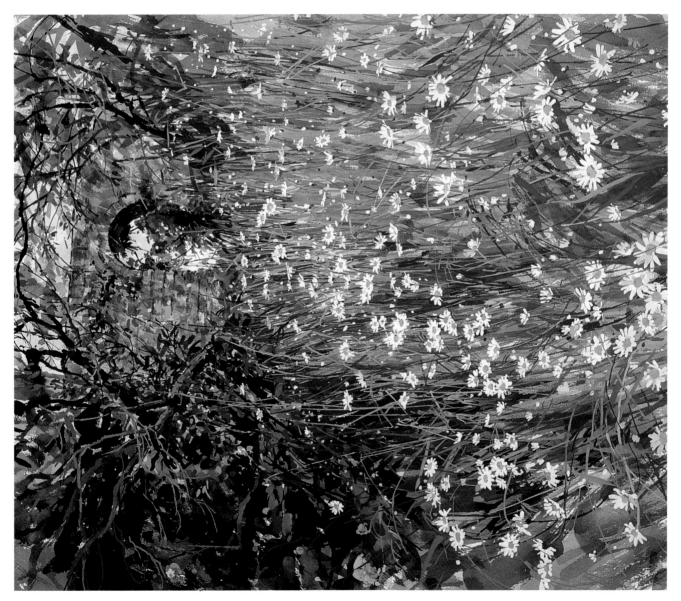

Bank of Daisies, Goodnestone
Watercolour, 1988, 20x18in (51x45.5cm)

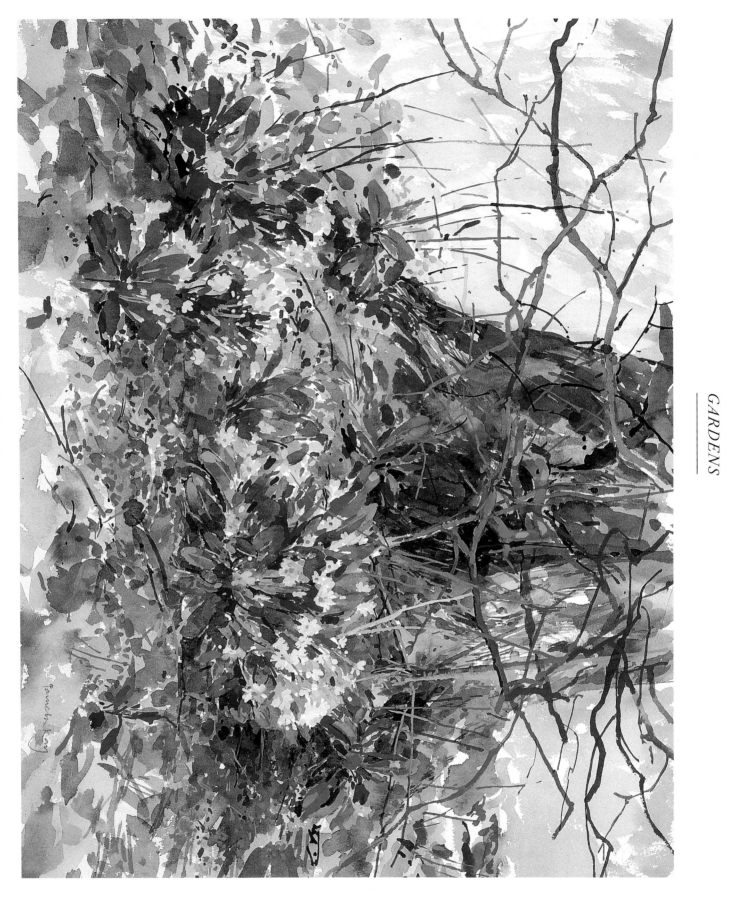

Woodland Primroses
Watercolour, 1991, 13x20in (33x51cm)

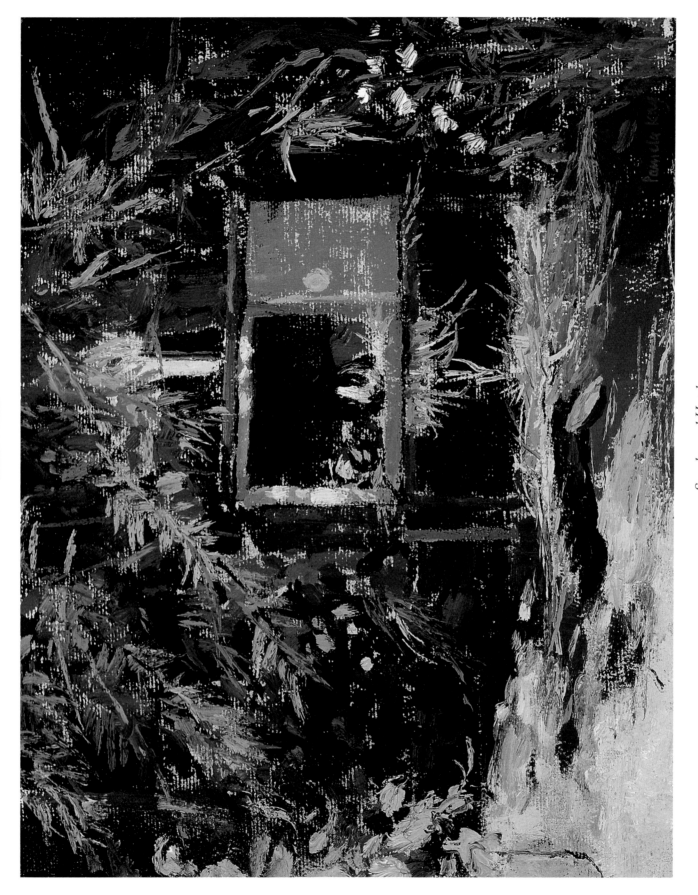

Starsky and Hutch
Oil on board, 1983, 8x10in (20x25.5cm)

106

'This was painted when the children were still quite small. They wanted a pet, and we were given a rabbit by one of the boys at Tony's school, whose father kept them. We knocked up a hutch for it, although I must say I don't like animals in cages. The rabbit was called Starsky because the girls were watching *Starsky and Hutch* on the television – a terrible pun! The hutch looked sweet at the bottom of the garden, with the straw dropping out. Behind it was a willow tree that has since died on us.

'When you have young children, the garden is essentially for them to play in, so it didn't really occur to me then to do much in the way of painting out there. Later I did a small painting of Hannah in the garden revising for exams, but that was about it until the children grew up. When the garden was no longer played in it started to grow faster, rather like when you go away on holiday and come back to find your garden is overgrown. As it got wilder it became more interesting and started saying to me that it would be lovely to paint.'

―――――――

While it is a reminder of the days *before* Pamela Kay painted her garden, this appealing little panel painting reveals the same interests in sunlight and shadow that we will see in her later work. Perhaps what is noticeable, though, is a slightly less conscious interest in the particularity of plants. The Naturalist garden painter was still emerging.

Here Pamela's skill as a Naturalist garden painter is convincing. The light and shade are believable, to the extent that one almost feels the warmth of the late summer sun and instinctively wishes to shield one's eyes. The painting is in three, rather than two dimensions: with the aid of conventional linear perspective, and a perspective of light and air (usually known as aerial perspective), the artist has created a credible picture space. Within this she has carefully

placed and described pots and plants on the paving.

'When we moved here the garden was already part-paved, because underneath is an air-raid shelter. I think it would have done as a nuclear bunker, because a builder lived here and made damned sure he was going to survive! As a result, our garden is 3 feet higher than everyone else's in the road. One shelter entrance was in the garden and the other by the back door of the house. With small children we didn't like this, so we bricked up one entrance and built a garage over the other. In the process, we wondered what else we could have done with it and decided that it would have

made a very good sheep-dip, but not much else.

'This is one of a series of paintings I made of the table, on which I put things to create still lifes within the garden. The table also gives a nice geometric shape against the foliage and is an oasis of white amidst the green. Behind is a shaded wall covered with dark green ivy, which is a marvellous counterbalance, in tone and colour, to the white tablecloth and the sunlit stone floor.

'As I got more interested in painting the garden I discovered that I could move the pots about, much as with a still life. Here I found it interesting to put the rich colours of the red geraniums and the scatter of pots in front of the cloth.'

Basket of Nectarines on a Table in the Garden
Oil on board, 1987, 10x13in (25.5x33cm)

Lilies in the Garden
Watercolour, 1987, 20x28in (51x71cm)

'I am very fond of this watercolour, which marks the time I discovered that if you plant three bulbs in each of several pots, cover them with some compost and then pray, you can get a sensational sea of magnificent lilies. They are ravishing for about a week, then they come and go for a short while, and then they will suddenly drop. And they were just wonderful to paint. In a sense I was taking the idea of painting large bunches of cut flowers into the garden setting and slightly enlarging upon it.

'I always think it's nice to be able to walk into a painting. If you feel that there is something just beyond the bunch of lilies in the centre, or just beyond the stems of the lilac bushes, that is an invitation to participate. The pots are really arranged as a guide into the painting.'

The lucid, sparkling handling of this work makes it the epitome of the summer garden watercolour. Its carefully orchestrated, painterly handling gives the scene a very defined sense of space and depth. With a mixture of wet and dry brush-work, the complex tonal range across the background has enormous interest and variety. In front of this the gradations of tone, becoming lighter in the foreground, give a delicious sense of the open air. Pamela Kay:

'As you can see, we have to go out to mow the patio! I have recently noticed that since I did this watercolour my paintings have tended to get darker, which I think is because the garden has become more overgrown. I hadn't realised that the sun was getting darker! Beyond the chair is a dense wall of ivy, which I am still reluctant to touch because it gives dark shadows and rich, deep greens. If I place pots with flowers in the light in front of this marvellous backdrop of dark tone, their colours sing. I move the pots around as if on a stage set to get different effects.

'Immediately behind the chair is a lovely pillar of sweet peas, called Mrs Kay. I tell my mother that they were named after her! Right across the back there is a constant change in the shapes and patterns of leaf, which it was important not to let disintegrate into blobs. There is a strong architectural framework behind, which, with the web of the paving, acts to hold it all together.

'I painted this watercolour in the afternoons, when the light was on the paving, which lasts for a couple of hours. When I am working in the garden I tend to have a whole series of paintings going concurrently, a bit like Monet did. He was no slouch; it's a very good system to work with.

The most wonderful thing about a series of this sort is when you get them all finishing off together and then they are completed in a run. It gives a tremendous sense of achievement as you stack all this work away, even though it will have taken quite a long period to come to fruition. Once I start a painting or a series, subjects pop up all over the garden – there are so many sitting there and shouting at me to be done. It's just a question then of saying, "Wait your turn, I've got to finish these ones first".'

Chair under the Apple Tree
Watercolour, 1988, 18x22in (45.5x56cm)

was so rampant. Since this picture was painted everything has become more overgrown and denser, and a buddleia has self-sown on the right, altering the whole light effect.'

'Here I have set up the picnic table as a dessert scene, with wine, fruit and a loaf of bread. For me the subject combines all the possible elements: still life, a tablecloth, food and the garden. Without wanting for it to become in any way a cliché or sentimental, I hope the result is still evocative.

'Again, I was attempting something on the grand scale and I particularly wanted to give it a lot of life. The angles of the paving squares and chairs zigzag across the foreground, and there is a lot of movement in the agapanthus lilies, the orange nasturtiums and the greenery at the back. They were not sedentary in nature, so they shouldn't be in the painting. You should also see some movement across the tablecloth, which the wind kept catching. I was standing as I worked, looking down on the scene as you would if you walked into a garden. It was done very loosely and at great speed to emphasise the feeling of constant movement.'

The handling is indeed quite calligraphic. Much of the foliage is, as it were, written rather than painted. Like the marks of an expressionistic cartoonist, linear sweeps of a vigorous dark brush overlay a fairly even-toned, lighter ground. On the far left the arching stems of the Fantin-Latour rose are an arabesque of moving lines. All that serves to stabilise this riot of flora is a solitary bamboo tripod, immediately behind the table.

The vivid sense of movement works well across this large area of paper, and yet the watercolour retains a light, summery touch. It is little surprise that the artist chose this as the central exhibit in her display as featured artist at the Royal Watercolour Society in 1989.

The Bottom of the Garden
Watercolour, 1988, 26x35in (66x89cm)

This large and ambitious watercolour, at the time Pamela's largest of the garden, takes a broad view straight down to the fence furthest from the house. Although contemporary with the *Chair under the Apple Tree* and handled with similar dexterity, the overall lighter hue and flatter composition suggest that she found organising the light and shade on such a scale a little daunting. Yet the effect is one of delight in the pleasures of gardening and pride in the achievements that so-called 'neglect' can bring:

'Where the paving had been neglected, dandelions, chives and even violets and cowslips were growing in the cracks, and I couldn't bring myself to pull them out. I moved the pots in front of the cane sweet-pea tripods and on the right is an also neglected tray of violas. On the left is the Fantin-Latour rose, and in the middle an old-fashioned deep-red rose is climbing up the trellis, giving a beautiful shower of colour. Also in there are the remains of the Kiftsgate rose, which I mentioned before, and which had to be removed because it

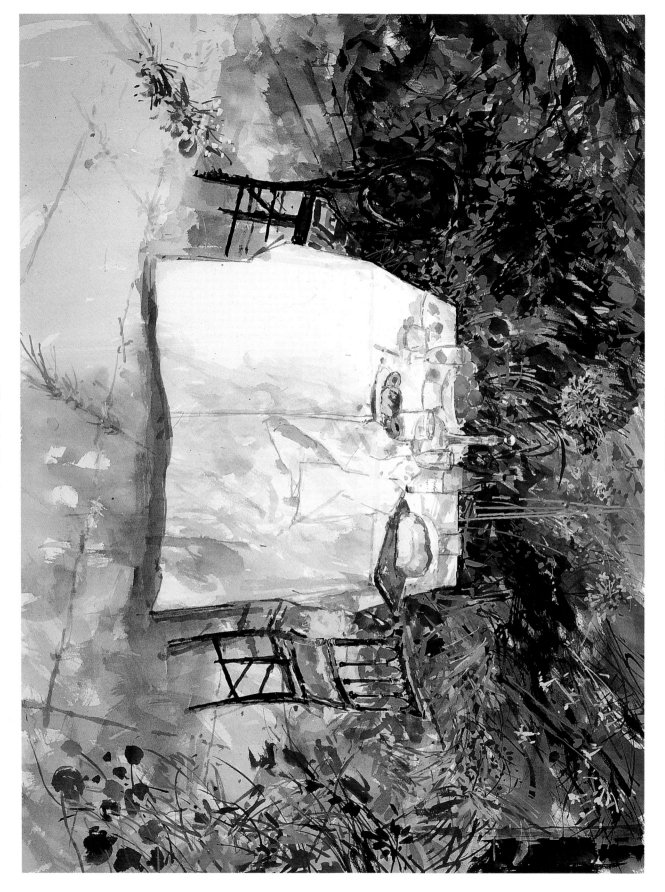

The End of Lunch
Watercolour, 1988, 26x35in (66x89cm)

111

'Here we are looking towards the house, with the conservatory windows in the background. This part of the garden has changed a lot since then. We have chopped down the tree on the left, beside which there was a fair amount of foliage. Set in front of a cascade of nasturtiums, roses and foliage is again a dessert table, set with a decanter, bread and a bottle of wine. In the foreground is a beautiful little Victorian Gothic chair.'

The whole scene has caught the sun and we can feel the warmth and balmy airiness of the garden. The vibrant brush-work is again close to the calligraphic, although softened by being oil on canvas. Although finished off in the studio the next January, this painting retains the immediacy of Pamela's time before the subject. Her spontaneous touch gives us the feeling of being present, almost to the extent of making us shield our eyes from the glare on the tablecloth.

'I saw these lovely chairs as we were driving past a shop in Canterbury and whizzed back to buy them. I particularly liked their linear spindliness. Now, of course, you can buy modern versions of this design in any garden shop, and I try very hard to avoid the cliché of this chair in the garden. Under the cloth is a lovely old card-table, and on top bread and fruit, some damsons and a few Michaelmas daisies. Behind is a mass of nasturtiums and Michaelmas daisies, on the left the strap-like leaves belong to an agapanthus, on the ground is a basket of violas and on the chair a basket of pears. The flower-pot at the back has a declining sweet pea in it, which again was a lovely linear thing.'

The keen observer will by now appreciate that Pamela Kay does not paint watercolour versions of oil paintings or vice versa. A variation on a theme, this canvas can be seen as the counterpoint, rather than the counterpart, in oil to the large watercolour entitled *The End of Lunch.* While in the latter the ability of watercolour to trace linear movement and to capture a light, open atmosphere was exploited, here the qualities of oil paint are used to convey the still lushness of a warm, late summer's day.

Around the heightened hues of the chairs, table and still life, freely painted passages of plants, pots and paving weave a rich tapestry of textures in greens and earth colours. The surface paint layer is very thin in places, allowing the sienna and ochre ground to show through and to help to unify the tones. The economy of handling suggests that the painting came together without too much of a struggle, as the artist explains:

'Occasionally I will suddenly come to a picture that falls into place on its own; both in its arrangement and its execution. This big oil did just that. From the beginning I liked the way the composition is concentrated at the top, from where a circular movement comes round to the base of the canvas.

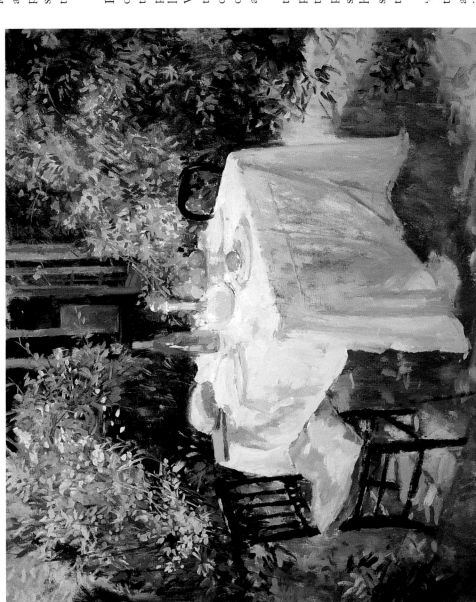

Summer Lunch
Oil on canvas, 1989–90, 18x22in (45.5x56cm)

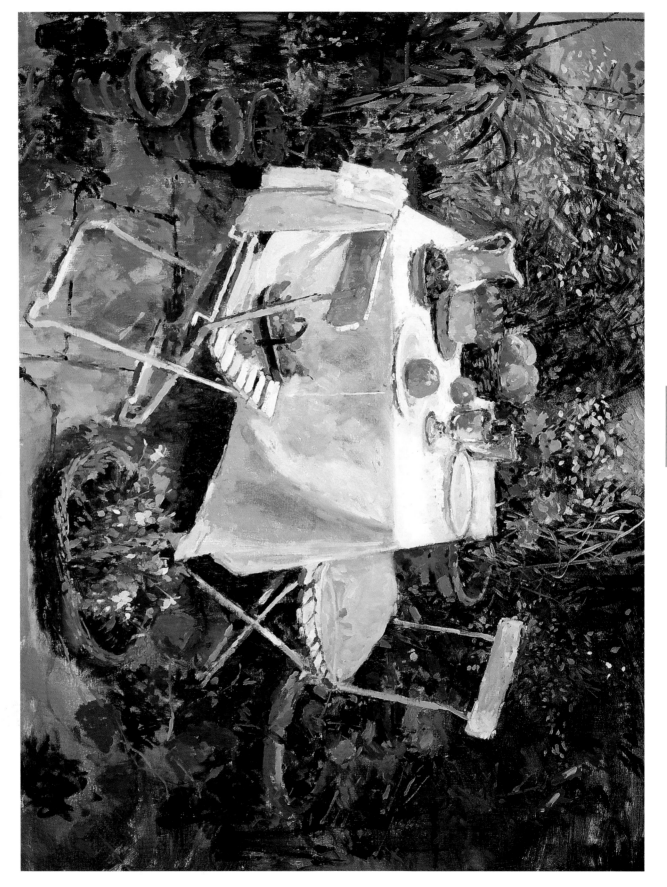

Late Summer Lunch in the Garden
Oil on canvas, 1988, 30x40in (76x101.5cm)

colour: dark green, dark blue and dark brown. And early in the morning, these lilies and some lovely pale pink field poppies catch the sun.'

'I am very fond of this painting, which is almost a combination of all the characteristics of the garden pictures. It was the first time I felt able to put in a figure and is certainly one of the most densely packed with detail. The setting is the same corner we saw in the large watercolour called *The Bottom of the Garden*, with the same bit of trellis on the right. But this is two years later and the place is totally overgrown with buddleia, a vine and two quite new roses at the back, and ivy has got in at the trellis and is eating away at it. I have also introduced pots of nasturtiums, pinks and marigolds.

'The whole scene has become altogether nicer: darker and richer. The colour changes on the buddleia are most interesting and the light picks up bits of its foliage that I can draw. Then there are the pinks and these marvellous marigolds, which are quite large at the bottom right, but get slightly smaller as your eye moves across the middle distance. The whole effect is of flickering colour and light over changes of green. It is very important to prevent green from being boring. If you can get all the viridians and the yellow-greens and the olive-greens and the grey-greens to work together, it becomes the most magnificent of colours. It is a matter of being faithful to each individual piece of greenery and then bringing it all together.'

Amid the abundance of nature, the artist's daughter sits in shade, while the midday sun beats down onto a white tablecloth and dramatically illuminates an arrangement of tureen, glass, plates and some strawberries. Pamela would only have been able to work on the sunlit foreground for a short time around noon, as this is a time when shadows are not simply lengthening or shortening, but are actually changing direction.

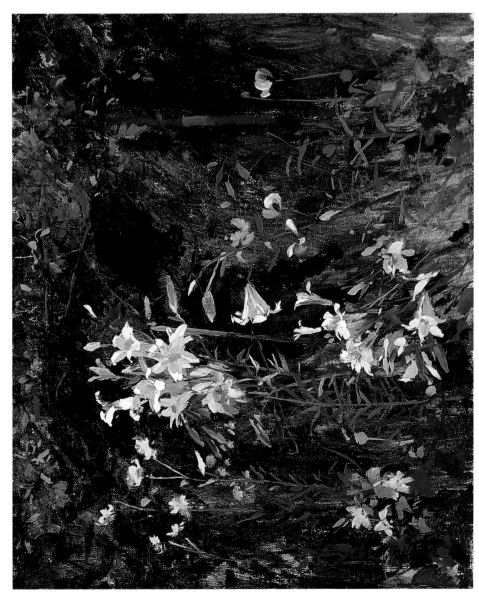

Lilies in the Sun
Oil on board, 1990, 9x11in (23x28in)

This jewel-like study is less structured than we have come to expect of even the artist's smallest board paintings. It suggests momentariness and inspiration; something fleeting, suddenly seen and dashed down in paint. It appears that no time was lost in composing, no effort made to variegate the background. Yet, of course, the composition is arranged with care and the backcloth purposefully selected. But the artist would not wish such considerations to come between the observer and the simple, elegant beauty of these white lilies against a rich, deeply shaded green and purple ground.

'This is one of those subjects that you have to do when you see it, and do very quickly. Some of the flowers were virtually transparent against the sun, and I kept the handling of those quite thin. But the lily petals turning up towards the sun are lovely big chunks of titanium white. Behind the lilies, right by the house, is an ivy-covered fence that is always in the shade. It has a really rich

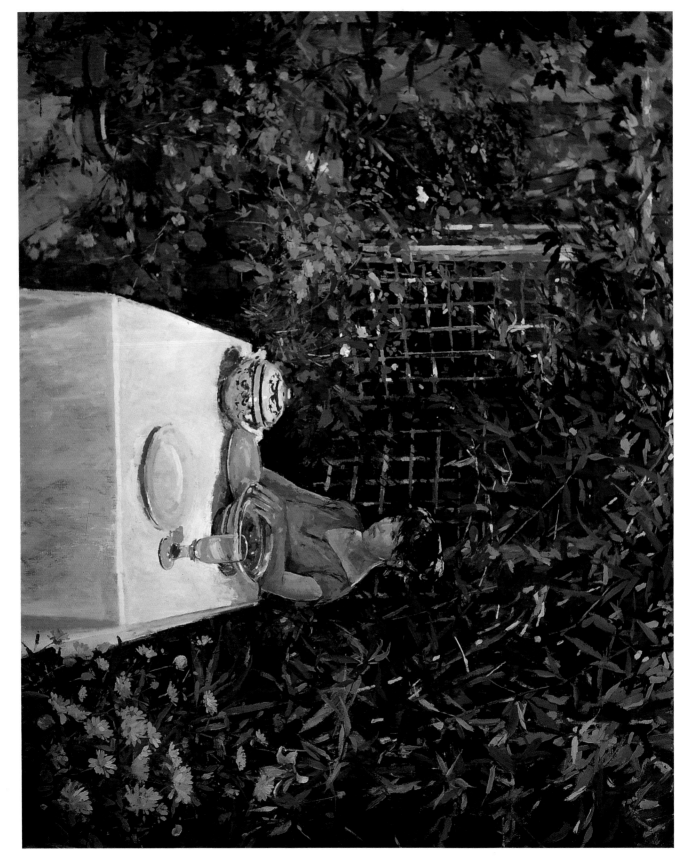

Summer Lunch with Victoria
Oil on canvas, 1990, 30x36in (76x91.5cm)

115

'I have to say that I put the washing-line up specially. I love washing-lines. There's a marvellous story about David Hockney's mother. David took his dear old mum out to California and apparently she looked out of the window one gorgeous, sunny day and said, "David, it's a lovely day, why hasn't anyone got their washing out?" That's so nice! People rarely have washing-lines today, especially in California, which is a shame, because they are lovely to look at.'

This time on canvas, and in the late afternoon winter sunlight, the clothes-line becomes the focus of attention. The sun catches the clothes, and the play of light and shadow is conveyed with spontaneous brush-work, making a most appealing image. Pamela Kay:

'I like this subject, because it is unusual and makes you look harder. If you are used to doing still life, suddenly moving on to something like this is a marvellous change of pace and discipline. This version was painted shortly after the night scene, and is the last and biggest of a series of four or five. After doing each one I would rearrange the washing, like you would a still life. These clothes went out dry and came in cold, damp and stiff as a board, but it was nice to be able to choose the colour. There was a pink shirt, a cream pillow-slip and a white sheet. The light is coming across, just below the pink shirt, and it's a wonderful ginger colour. While the snow was there, I thought I couldn't waste it.'

Snow at Night
Oil on board, 1991, 9x10in (23x25.5cm)

As with *Lilies in the Sun* before it, Pamela has seen here an image for painting, and it has been painted. Sitting in the warmth of her kitchen, she peered out one night at the snow, which was starkly lit by the garden light. The strange illuminated shapes in the foreground (steak-and-kidney pudding lids as Pamela describes them) are the principal interest in the painting, and their handling is brief and pleasing to the eye. The washing hangs cold and stiff, as if the snowfall was unexpected.

'This shows you that I am not a plantswoman. Most gardeners are clever enough to have plants that look nice, whatever the time of the year. My garden is totally denuded in the winter – barrack bare and rather grim. But it is better when it snows and the trees look lovely.

The Pink Shirt in Snow
Oil on canvas, 1991, 16x20in (40.5x51cm)

117

is a hint of the trailing rose, Cécile Brunner, which just catches the light. In the foreground are some poppies and a bed of geraniums and bellis daisies. I particularly like it when the light comes through these pink poppies and they become transparent.'

From the same series, this slightly larger panel is a reminder of the fickle nature of our summers.

'This is the garden after it had just rained. I suddenly realised that there was no need ever to sit and do nothing, waiting for the sun to come out, least of all when it was raining in the garden. I sat in the conservatory, which joins onto my studio, looking out through the door and towards the end of the garden. The chair had been left there from another painting and in the foreground there were pots of trailing nasturtiums in front of growing Michaelmas daisy shoots, which were still just green leaves. And there were lovely reflections on the wet flagstones.'

For once the artist did not have the opportunity to arrange her subject, and the composition, if not correspondingly artless, is noticeably unselfconscious. Again, the brush-work is broad and, presumably, rapid in execution. The dark, heavy tones capture the damp mood of a wet summer's day with conviction. The signs of water on the paving are the obvious signal of the conditions, but in fact each brush-stroke seems to carry some tell-tale sign of the dank atmosphere.

Breakfast – Early Morning Light
Oil on board, 1991, 9x11in (23x28cm)

The summer following the snow subjects Pamela Kay decided to make another series of small paintings of the garden. They are among the most direct and liberated of her works. This array of flowers, seen in the clear morning sunlight against the now familiar ivy fence, is painted with lucidity and assurance. Although we know the still life has been set up for the purpose, no sense of artifice interferes with the easy Naturalism.

'I painted the flowers very broadly, so that they are a ripple of light and colour against the dark tone of the ivy and the mid-toned colours of the table itself. In this case it was vital to have something like the table as an architectural shape, offsetting the random thrashings of the foliage in the front. Like the more formless *Lilies in the Sun* it was painted very quickly, because the morning sun moves fast.

'On a trellis in the top right-hand corner there

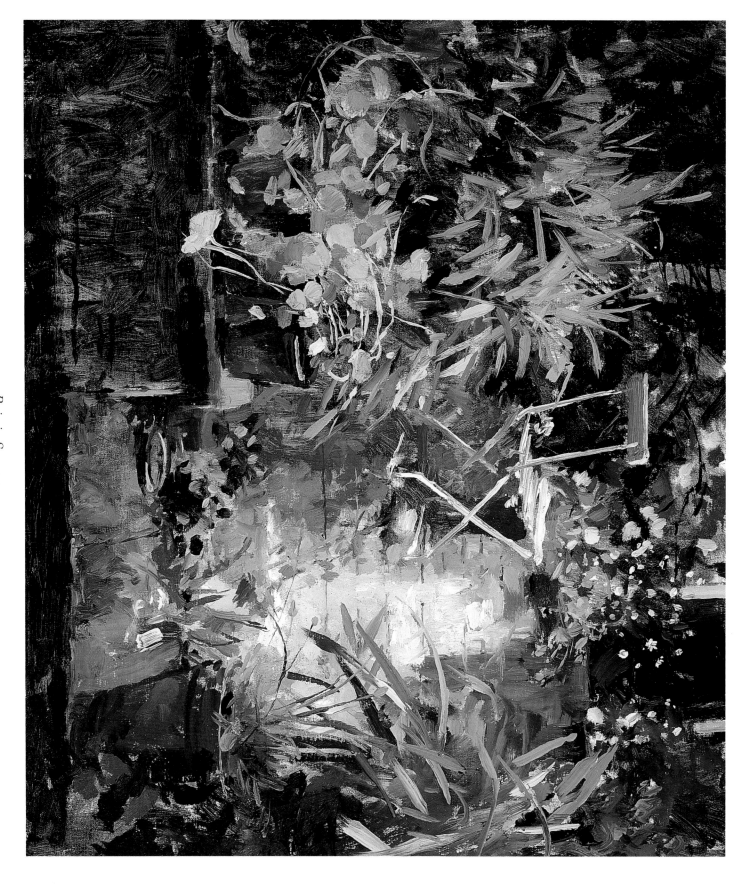

Rain in Summer
Oil on board, 1991, 12x14in (30.5x35.5cm)

This canvas bears comparison with the similarly sized *Summer Lunch with Victoria*, painted about one year earlier; the setting is similar and some similar flowers are blooming. Otherwise, the table has gone, Victoria has gone to stand in a newly opened vista past the trellis, and her silhouette is caught against a blazing cascade of roses.

These changes have opened up the picture space and mark significant pictorial developments. The artist has moved from the flattened,

almost two-dimensional setting of the figure in front of a floral backdrop, to an open stage, in which carefully controlled lighting on a series of receding pieces of scenery creates a three-dimensional picture space of great depth. It seems that every element of the composition is in its correct place and that each flower, each leaf, each brushstroke is making its contribution. Just as many of the artist's still-life arrangements can appeal to the intellect as well as to the senses, so too, does the construction of this beautiful painting.

This is not to imply that it looks unnatural. Pamela is faithfully depicting her garden as she has arranged it. That she rearranges the garden for a painting is merely an extension of normal gardening. All that has happened is that she has become more assured and more creative with her subject than when she first tackled it a year before.

The detailed illustration suggests that the paint went on with some ease. It is not apparent, however, that this area was troublesome, causing the artist to reduce the size of the sitter's head a fraction some time after the picture was finished, thus deepening the picture's perspective and improving the relationships of shapes in that area. Pamela Kay:

'If there is something that continues to bother me about a picture I have to do something about it. When it's a big and, for me, important work, I have to live with the painting and consider it for quite a while. Here the head was a little too prominent. It is an important part of the painting, positioned against the rose, but I only wanted to suggest the figure and it had to be just right.

'Instead of the predominant oranges of nasturtiums and marigolds in the other painting, this time there were also white ox-eye daisies and petunias, as well as the white chair. So the whites and the greens really give this a different colour scheme, despite the marigolds at the front. I added the tray with a napkin to give a bit of still life in the foreground and so bring the picture one stage nearer the viewer. I hope its angle leads you into the painting.'

The Garden in July
Oil on canvas, 1991, 30x36in (76x91.5cm)

The Garden in July
(Detail)

Another of the series painted in the summer of 1991, this dashing study conveys all the movement and life of an herbaceous border, seen against the more static presence of the artist's favourite Gothic chair. Freely drawn arcs of dark, overhanging foliage sweep over the upper half of the painting and emphasise the sunlit patch of white flowers.

'This is half-way down the garden on the left-hand side, in front of the Fantin-Latour rose-bush, which still had a few flowers. The bush is supported by a chestnut paling that we made. I think it's a humane way of supporting it and gives this nice arched shape.

'I did the painting rapidly in mid-morning, when the light gets to that part of the garden. Be-

hind the chair was a huge clump of feverfew, a tiny single chrysanthemum-type daisy, which grows wild in the garden. It was very light in tone and the chair was beautifully silhouetted against it. There were still a few nasturtiums at the back and poppies in the front, giving a kick to the colour.'

On a gloomy November day spent interviewing the artist inside her house, this little study was almost painfully reminiscent of the high summer that this series so beautifully evokes. Here the effect of dappled sunlight is particularly telling and is painted with close observation and a free brush. The picture is given structure by the partly shaded, but otherwise glistening white paintwork of the trellis framework, before which a pattern of brilliant blooms is strewn across a dark background like galaxies against the night sky. Looking out onto the grey paving-stones that day, it was difficult to imagine that the light could be so bright and the air so warm ever again.

'This is the bottom of the garden. The splash of small pink blooms is a new climbing-rose, which I think is called New Dawn, and is a beautiful pink, with small flowers. It is taking over almost as rampantly as the Kiftsgate rose, but is prettier and more manageable. In this picture it makes a lovely showery effect as it comes into the light on the trellis. The eye then moves down to nasturtiums in pots in the foreground. Again this was done very rapidly and is really all about light.'

Victorian Chair under the Apple Tree
Oil on board, 1991, 9x10in (23x25.5cm)

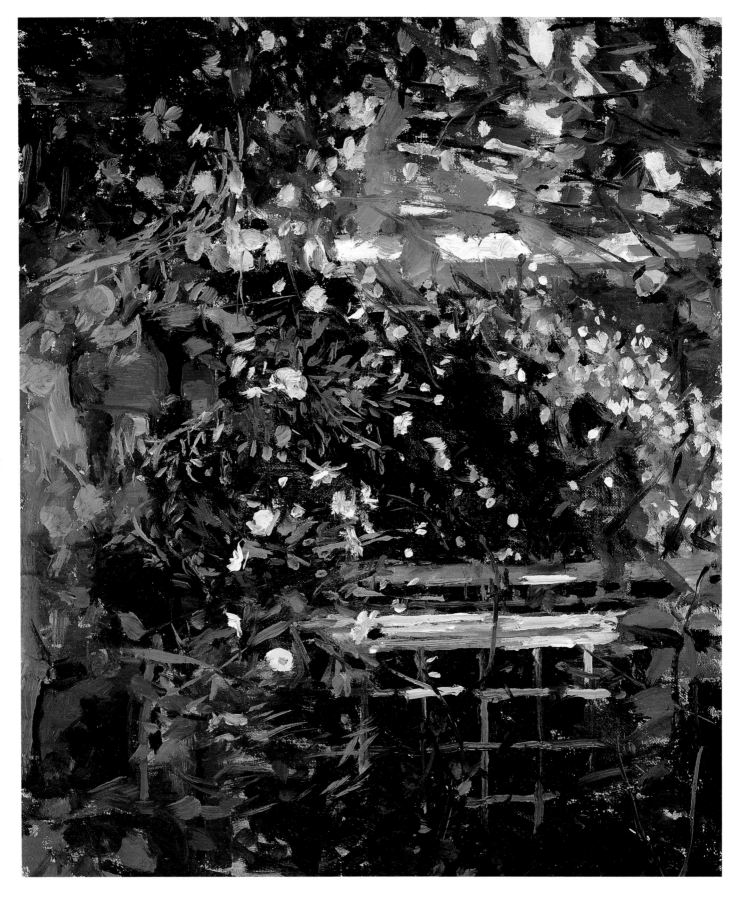

Rose Trellis, Afternoon
Oil on board, 1991, 9x11in (23x28cm)

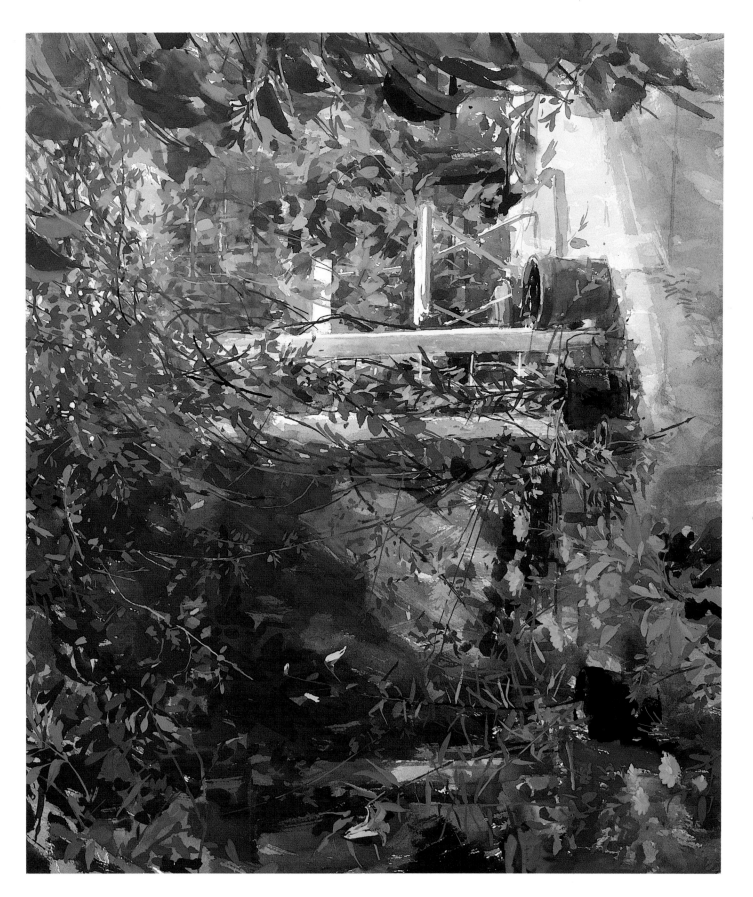

Chair in the Sunlight
Watercolour, 1991, 18x22in (45.5x56cm)

124

'These two pictures were painted in the same spot in the garden, near the house, which is visible on the right. The left-hand side is the dark patch of ivy, where *Lilies in the Sun* was painted. The rose over the trellis is the climbing Cécile Brunner.

'Both pictures are concerned with the difference between the light streaming through the archway and across that particular corner, and the dark area behind. It is clearly a paradox, but you can only have a really dark corner if you have a strong light on it.'

Each with its own character and floral displays, these two works could pose niggling, botanical problems for any future art historian. In order to pre-empt such misery, it might be explained why lily and rose are seen at differing stages, yet the marigolds survive both paintings unruffled, as the artist explains:

'They were painted concurrently over a period of time, and I would hop from one to the other. You can see the development of the various plants through both pictures, although not necessarily in a logical way. After I had finished the marigolds in the oil I saw that there was a hole in the foreground in the watercolour. As the marigolds provided the right accent of colour, I decided to use them again in the foreground of the watercolour, something I would not normally do.

'I wanted to get richness of colour and shape in both paintings. I think it was particularly important to get changes in the green areas, from the extreme right-hand side to the trellis. As you move across, the scale differs too, and there is constant variety.

'I put the figure of Victoria in the oil and not in the watercolour because I'm a coward. It is very difficult painting a figure into a setting like this, and if I made a mistake I could correct it much more easily in oil than I could in watercolour. It turned out that I did want to change the figure.

Anyway, the chair was lovely and I wanted to do it on its own, too, and it was somehow more appropriate in watercolour.'

One almost senses that when Victoria came out to read, the artist swapped from the watercolour to the oil, and then vice versa when her model retired to the house. As the artist suggests, it is noticeable that figures appear rarely, if ever, in her watercolours.

Although the integrity of its medium is preserved, even emphasised in each picture, both successfully capture the appropriate amount of lushness and depth of colour and shade of their

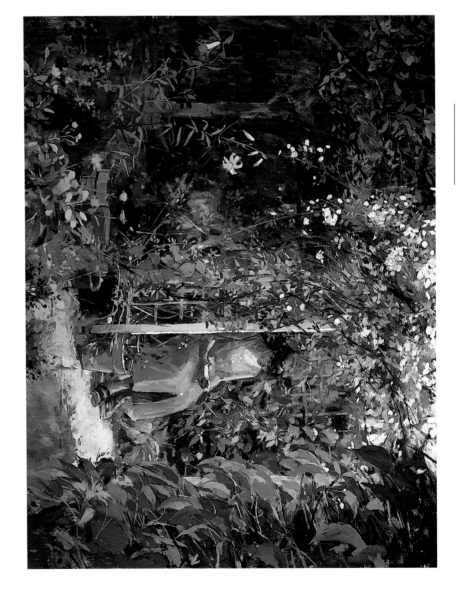

Victoria Reading in the Garden
Oil on canvas, 1991, 24x30in (61x76cm)

subject. Try covering over Victoria and her blue dress, however, and you will see how heavily the canvas's composition relies on her presence: the verdant scene seems flat by comparison with the watercolour, which only has a white chair to offer by way of competition. The artist may have changed medium as her subject changed, her model moved or her flowers dropped, but she always knew what was going where, and why.

The prominent compositional feature of the painting is the double curve – Hogarth's 'line of beauty' – bending round through the sunlit twigs, straightening in the middle ground and then twisting down again, around the pots and toward the spectator. Intersecting the middle of the double curve is a diagonal axis based on the step and plant-container. Supporting these linear elements is a solid pictorial framework, including the fence, which defines an important plane at the back and the step which defines the ground levels. The arrayed flowerpots are carefully placed, but mingle informally, like bit-players in a crowd scene.

The real excitement of the canvas is the raking red light that makes a burning bush of the foliage to the left. Over the smoky blue of a winter's day, the sweeping drawing of branches in browns and gingers, and vigorous dashes of a cadmium red-loaded brush ignite the canvas. By direct contrast, the right of the composition is a dark, cold hole, which is pushed back by the glint of sun on some nearer twigs. Pamela Kay:

'The flicks of cadmium red on the right are vital in that they kick the dark area into life. The upturned V in the corner is a bit of the Cécile Brunner rose that caught the sun, and the diagonal stripe is a lit-up lily twig. I had left all this dead foliage in the anticipation that it might snow and I would have an interesting snow painting. Of course, it never did snow that winter! But the twigs were perfect for this subject, and all I had to do was watch until the light was right. This is something I could only do in my own garden.

'In the back of my mind was the Monet painting, *Autumn Effect at Argenteuil* (1873), in the Courtauld Institute, and particularly his handling of the brush. Of course, the marks you make are only what you do to get the effect you want, and are not an end in themselves. But I realised from Monet's painting the importance of keeping the brush-marks crisp and sharp and the colour clean, and that kept this picture bubbling.'

The Garden in Autumn
Oil on canvas, 1992, 24x30in (61x76cm)
[Detail right]

'This is a real Sunday painter's picture. I took it easy and painted this from inside the kitchen! I could only work on the canvas between 12.30 and 2.30 on December days, when the sunlight was bright and low, coming right across the composition. The advantage in working inside was that all my concentration could go into the painting: I wasn't thinking, "Oh dear, I'm cold. I must go and have a cup of tea."

'Making a painting that relies so much on a particular light can be difficult in England, because the weather is so unpredictable. While I was painting this, I was also doing a number of other things, which could be dropped when I wanted to switch to this canvas. If, when I got up, the morning was clear, I would set this up in the kitchen, then work on something else until the time was right. If the sun wasn't shining at that moment I would paint in the dark areas or draw some branches, so that I would never actually waste any time. The minute the light was right, I would go at it hammer and tongs.'

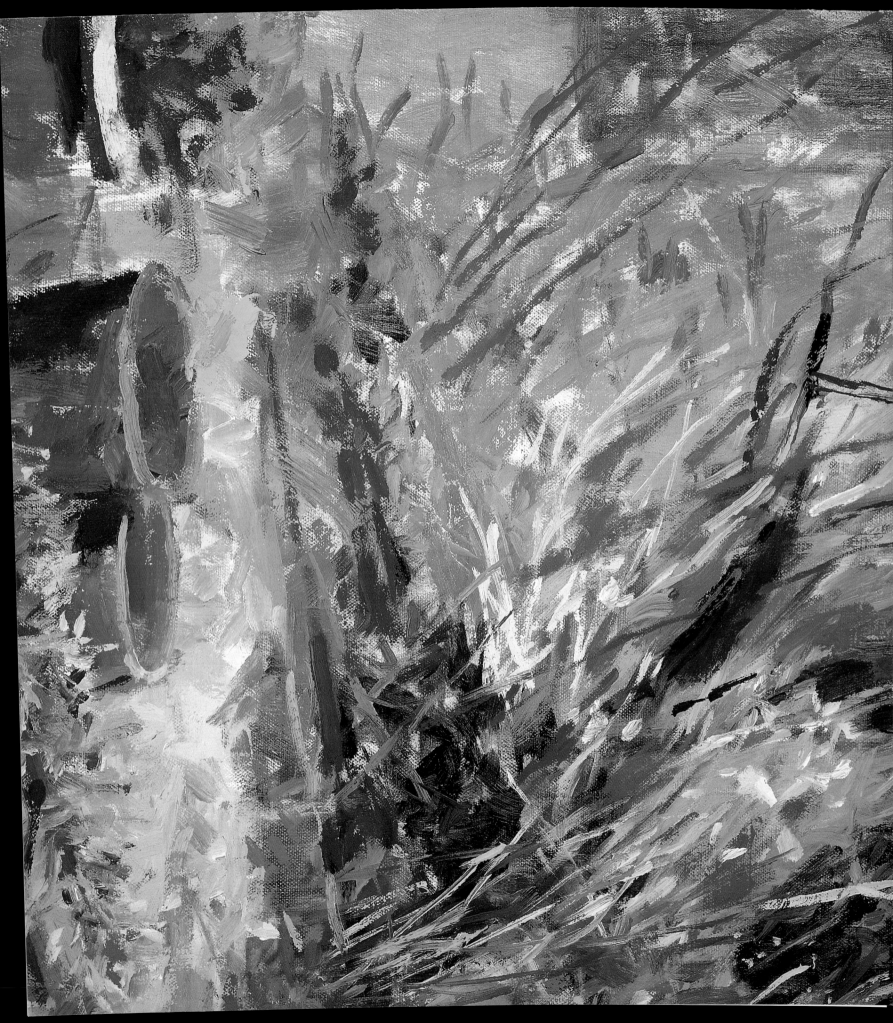